IMAGES
of America

STEUBENVILLE

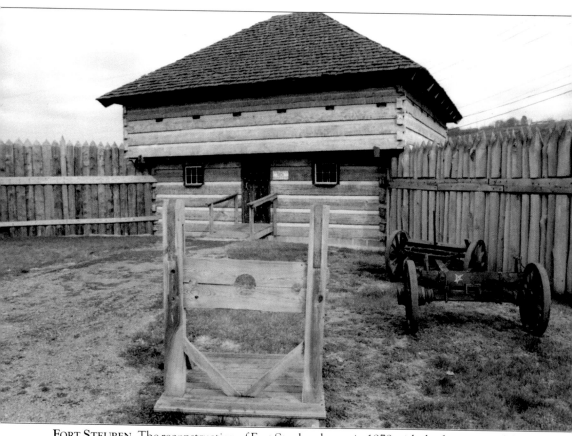

FORT STEUBEN. The reconstruction of Fort Steuben began in 1979 with the formation of the Old Fort Steuben Project Committee. After land acquisition, the first blockhouse was reconstructed in 1989. The entire fort was completed by 2000, providing an exact reconstruction of the original fort that protected the surveyors in 1786–87. The site is open to the public as a living part of history of the Frontier Period. (Photograph by Ron Smith.)

(*Cover*) **1897 CENTENNIAL PARADE.** Steubenville celebrated its 100th anniversary in 1897 with an elaborate parade through the downtown streets. The Reverend James J. Hartley is marching with many children from Holy Name Parochial School in the parade as it proceeds down Market Street. He later became the Most Reverend James J. Hartley, serving as Bishop of Columbus Diocese. (Public Library of Steubenville and Jefferson County Ohio Collection.)

IMAGES
of America

STEUBENVILLE

Sandy Day and Alan Craig Hall

ARCADIA
PUBLISHING

Copyright ©2005 by Sandy Day and Alan Craig Hall
ISBN 978-0-7385-3399-5

Published by Arcadia Publishing
Charleston, South Carolina

Printed in the United States of America

Library of Congress Catalog Card Number: 2005920493

For all general information contact Arcadia Publishing at:
Telephone 843-853-2070
Fax 843-853-0044
E-mail sales@arcadiapublishing.com
For customer service and orders:
Toll-Free 1-888-313-2665

Visit us on the Internet at www.arcadiapublishing.com

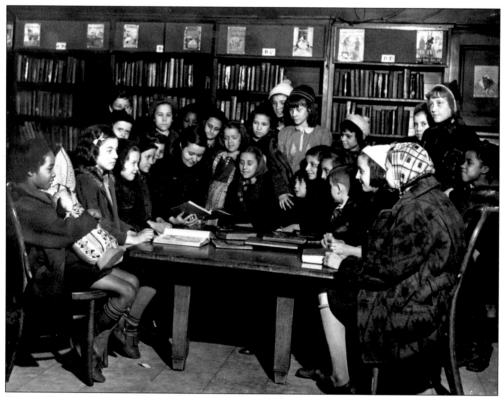

STORY HOUR. A group of young people is gathered in the Reading Room of the Carnegie Library of Steubenville in 1938 to listen to the librarian read a story. The library was constructed in 1902 with $62,000 in funds from Andrew Carnegie, the third library in Ohio funded by Carnegie following Sandusky and East Liverpool. (Public Library of Steubenville and Jefferson County Ohio Collection.)

CONTENTS

ACKNOWLEDGMENTS

We would like to thank everyone who has donated books, photographs, and information to the Public Library of Steubenville and Jefferson County that has allowed the Local History and Genealogy Department to develop and grow over the years. Much of that material from the Ohio Collection of the library has been used for this book and is designated "PLSJOC." A special thank you goes to Ron Smith for the contribution of his photographs for the book. Proceeds from the sales of this book will support the services of the library collection. Arcadia Publishing, and our editor Melissa Basilone, deserve thanks for believing in this project and for providing a means of sharing these photographs and this information with the nation.

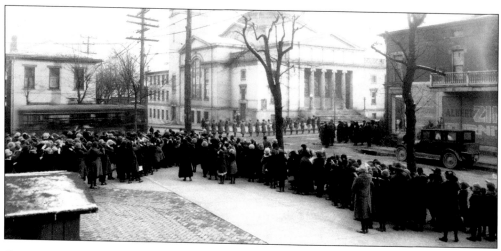

GROUNDBREAKING OF GRANT SCHOOL. In 1925, groundbreaking ceremonies were held for construction of the new Grant School, replacing a 1870s building of the same name at South 4th and South Streets. The school is to the left. Onlookers are watching the marchers salute the flag in front of Calvary Methodist Church while the streetcar goes by. In 1945, that church building would be purchased by the Holy Trinity Greek Orthodox Church. In 2004, the school building was demolished. (PLSJOC.)

INTRODUCTION

In 1783, the Treaty of Paris was signed and the new United States government received the Old Northwest Territory, the land west of the original 13 colonies and the Appalachian Mountains. Today, it is the states of Ohio, Indiana, Illinois, Michigan, Wisconsin, and part of Minnesota. The sale of the Old Northwest Territory was needed to retire the debt of the American Revolutionary War and to give to veterans as payment for their services in the war. With the ratification of the Northwest Land Ordinance by Congress on May 20, 1785, the survey work began. U.S. Geographer Captain Thomas Hutchins started the survey on September 30, 1785, at the point where the western boundary of Pennsylvania crosses the Ohio River, today near East Liverpool, Ohio. The geographer's line was extended due west for 42 miles, six miles per range. This tract of land, called the Seven Ranges, was to be sold to settlers.

The survey work was slow, and Congress wanted it completed so land sales could begin. Captain John Francis Hamtramck was dispatched from Fort Harmar with soldiers to establish a fort to serve the surveyors so they could complete their work. Captain Hamtramck named the outpost Fort Steuben, in honor of the Prussian Inspector General of the Revolutionary Army, Baron Frederick William Augustus Henry Ferdinand Von Steuben. The fort served as an outpost, providing protection for the surveyors and allowing them to complete their work. Fort Steuben was decomissioned in May of 1787, as the Fort's work had been completed. The soldiers marched to Fort Harmar at Marietta, and the supplies were taken to Fort Henry at Wheeling, Virginia (now West Virginia). By 1790, Fort Steuben had disappeared from the scene, but its site was used as a camp site by passing settlers on their way into the Ohio Country.

Steubenville was established in 1797 when Bezaleel Wells and James Ross purchased the land for the city. The first Federal Land Office was located here in 1800 and continued to operate until 1840. That Land Office was rediscovered in the 20th century and has been restored near its original site. Fort Steuben has been reconstructed adjacent to the Land Office and today sports a new Visitor's Center—it is the only fully reconstructed fort in Ohio from this era.

STEUBENVILLE STEEL PLANT. The Weirton Steel Corporation's Steubenville Plant turned out 70,000 artillery shells per month during production during World War II. Steelmaking began as early as 1817 in Steubenville, with this plant constructed in 1905 as the Pope Tin Mill. (PLSJOC.)

One

FAMOUS SONS AND FOUNDERS

BEZALEEL WELLS. Wells was one of the founders of Steubenville in 1797. A surveyor from Maryland, he received 1,000 acres as payment for his services to the government. This land was located on the west side of the Ohio River. Together with James Ross, they laid out the town of Steubenville, naming it after Fort Steuben, which was erected here in 1786. Bezaleel Wells performed all of the surveying for the new town. He died in 1846 and is buried in Union Cemetery. A painting of Wells, done for the 1897 Centennial Celebration, hangs today in the Main Library of the Public Library of Steubenville and Jefferson County. (PLSJOC.)

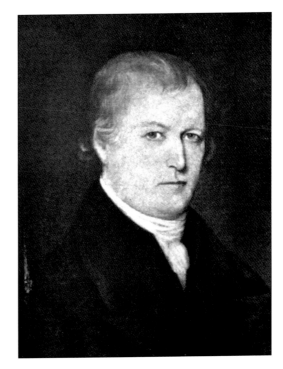

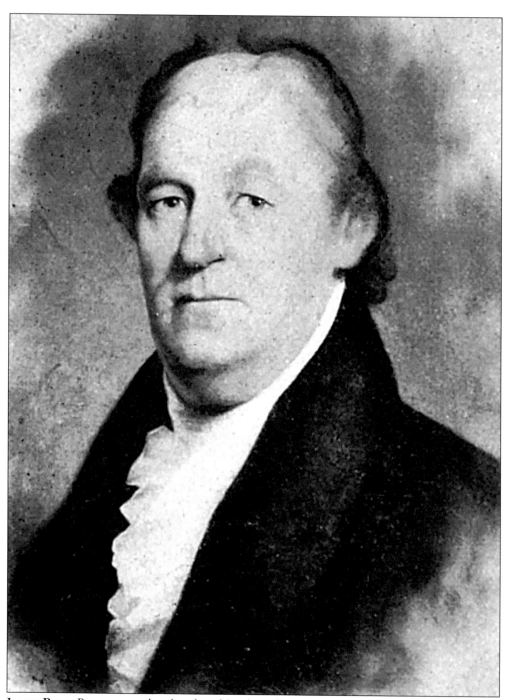

JAMES ROSS. Ross was another founder of Steubenville in 1797. An attorney from Pennsylvania, he never actually lived in the city. He was an associate of Bezaleel Wells and played an important role in the city's founding. He was a candidate for governor of Pennsylvania in 1798. Ross County, Ohio, was formed that same year and was named for Ross. A painting of Ross, done for the 1897 Centennial Celebration, hangs today in the Main Library of the Public Library of Steubenville and Jefferson County. (PLSJOC.)

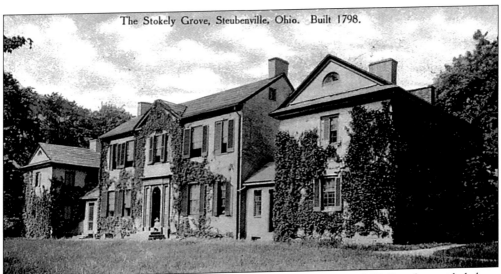

The Stokely Grove, Steubenville, Ohio. Built 1798.

STOKELY GROVE. This mansion was constructed in 1798 by Bezaleel Wells, who resided there until about 1830. He called it "The Grove." General Samuel Stokely and his family occupied the home until 1903, renaming it "Stokely's Grove." The mansion was located near the intersection of 3rd and Slack Streets, across a ravine from the streets. At the time of its construction, the home was one of three mansions to occupy the Old Northwest Territory, the other two being the Blennerhassett Mansion near Parkersburg, Virginia, (now West Virginia) and Thomas Worthington's home called "Adena" at Chillicothe, Ohio. The mansion and property was sold to the Pope Tin Mill, which demolished the structure in 1905. The Mill later became the Steubenville Works of the Weirton Steel Corporation. (PLSJOC.)

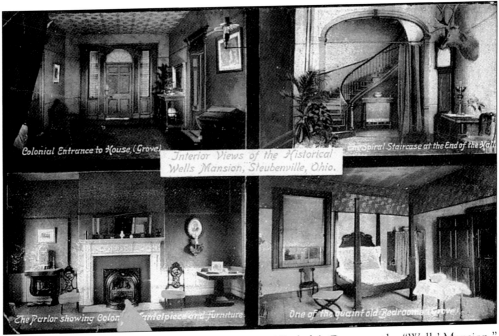

Colonial Entrance to House, (Grove)

Interior Views of the Historical Wells Mansion, Steubenville, Ohio.

The Spiral Staircase at the End of the Hall

The Parlor showing Colon Mantelpiece and Furniture

One of the quaint old Bedrooms (Grove)

STOKELY GROVE INTERIOR. These interior views of Stokely's Grove, or the "Wells' Mansion," show what the mansion's inside looked like in its heyday. (PLSJOC.)

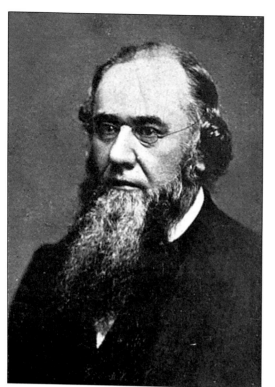

EDWIN M. STANTON. Stanton was born in Steubenville in 1814 and was President Abraham Lincoln's Secretary of War. He was also an attorney, having studied law in the city, and had his law practice here. Just days prior to his death in 1869, he was appointed to the U.S. Supreme Court by President Grant. Stanton is buried in Oak Hill Cemetery in Georgetown, near Washington, D.C. (PLSJOC.)

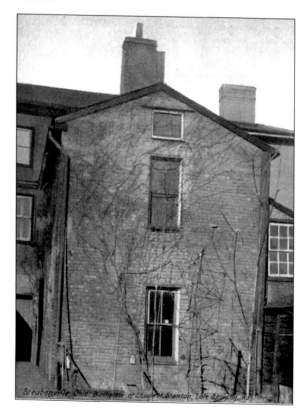

STANTON'S BIRTHPLACE. Edwin McMasters Stanton was born here on December 19, 1814. His birthplace, shown here, was a two-story brick house located on Market Street between 5th and 6th Streets. The building no longer remains, but a marker was dedicated in 1897 for Steubenville's Centennial Celebration and is attached to a stone at The Towers, 500 Market Street. The marker reads, "Edwin M. Stanton, Attorney General, Secretary of War, Justice of the Supreme Court, Born here 19th December, 1814, erected by the School Children of Jefferson County, A.D. 1897." (PLSJOC.)

Two

1897 CENTENNIAL AND 1947 SESQUICENTENNIAL

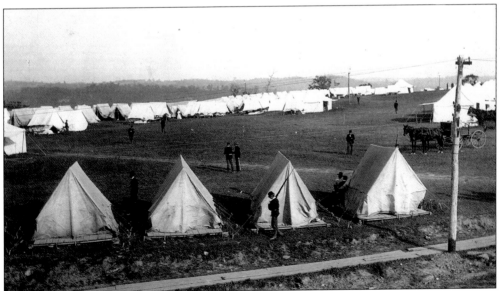

1897 CENTENNIAL ENCAMPMENT. In 1897, Steubenville honored its centennial with a celebration on August 24–26. Many of the events extended over the entire summer. Here is an encampment on Pleasant Heights, a new neighborhood being established on the hilltop west of the downtown area. Before house construction, this encampment was established for the celebration. (PLSJOC.)

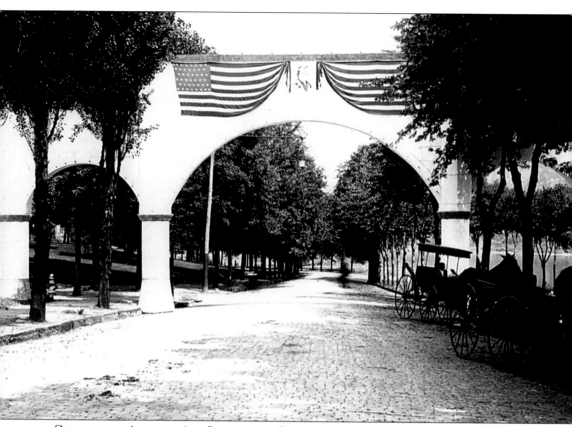

CENTENNIAL ARCH AT 4TH STREET AND FRANKLIN AVENUE. This is one of the Centennial Arches erected in Steubenville to honor the 100th anniversary of the founding of the city. This arch was constructed over North 4th Street at Franklin Avenue, looking north towards the Ohio River. Today, a modern arch occupies the site, designating the North 4th Street Historic District. (PLSJOC.)

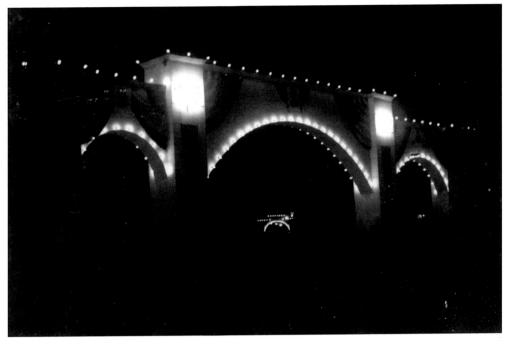

CENTENNIAL ARCH AT 4TH AND MARKET STREETS. The Centennial Arches were lighted at night, an early use of decorative outdoor electrical lighting. This is the arch at 4th and Market Streets in downtown Steubenville, with the Arch at 6th Street in the distant background. (PLSJOC.)

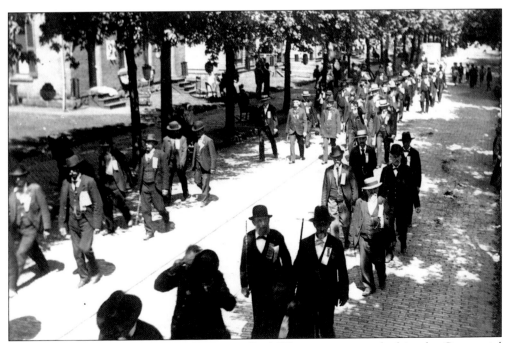

THE GAR IN THE CENTENNIAL PARADE. Civil War veterans marched in the Centennial Parade as the GAR, the Grand Army of the Republic, their veteran's organization. (PLSJOC.)

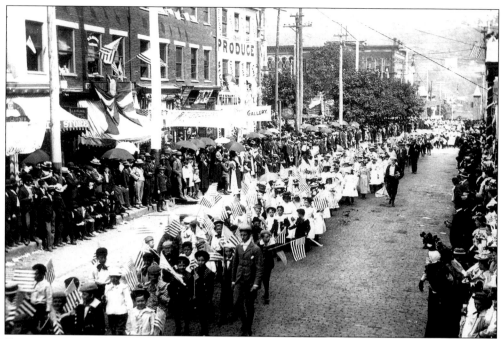

CHILDREN MARCH IN THE CENTENNIAL PARADE. Children march in the Centennial Parade on Market Street near the corner with 4th Street. The Court House is behind the trees in the photograph, with the hills of West Virginia in the distance. (PLSJOC.)

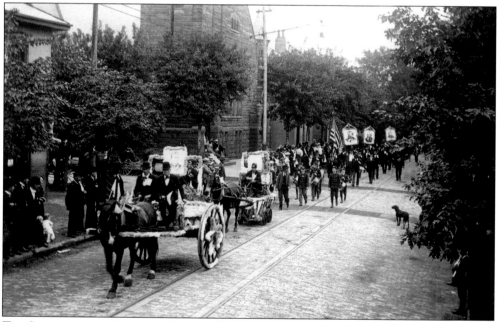

THE STEUBENVILLE COAL AND MINING COMPANY FLOAT. The Steubenville Coal and Mining Company had this float in the Centennial Parade. It is moving south on North 4th Street. A horse and cart are pictured in the front of the display; the rear vehicle is a mining car with steel wheels, used in a coal mine. (PLSJOC.)

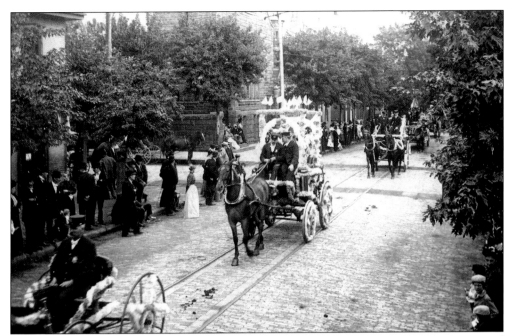

THE FIRE DEPARTMENT IN THE CENTENNIAL PARADE. The Fire Department is represented in the Centennial Parade with this horse-drawn wagon, all decorated for the occasion. Fire Chief Barney Martin is in the front of the wagon, with Firemen Kell, Quimby, Ovington, Fell, Davidson, Weaver, Beatty, and Morrow completing the parade delegation. (PLSJOC.)

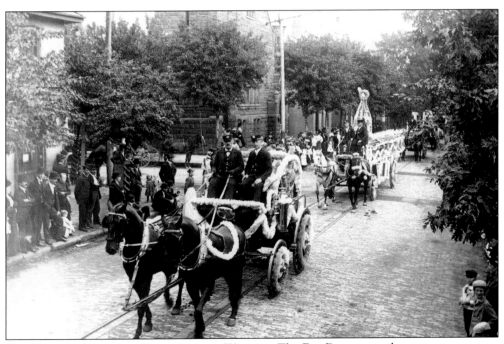

THE FIRE DEPARTMENTS HORSE-DRAWN WAGONS. The Fire Department has two more wagons in the Centennial Parade. This is the second horse-drawn wagon with firemen aboard, followed by a larger wagon with ladders attached to the sides decorated for the occasion. (PLSJOC.)

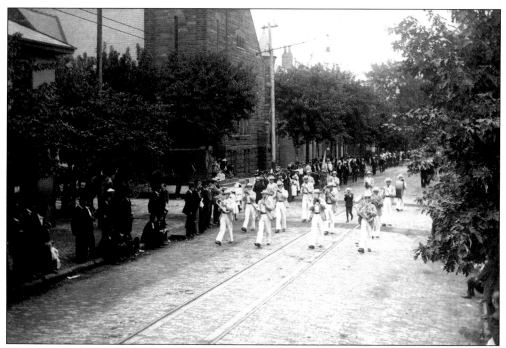

Patton's Band. Patton's Band is marching in the Centennial Parade, likely playing a lively patriotic tune as they pass North 4th and North Streets. Note the streetcar tracks; in 1897, the streetcar line was new, accounting for the good condition of the brick street, much of which would have been rebuilt by the traction company. (PLSJOC.)

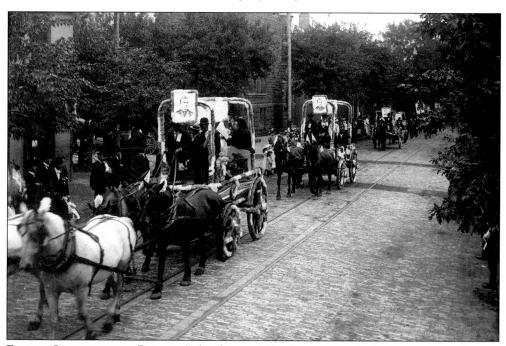

Famous Citizens in the Parade. Behind Patton's Band are wagons displaying portraits of famous Steubenville citizens, with family members riding in the horse-drawn wagons. (PLSJOC.)

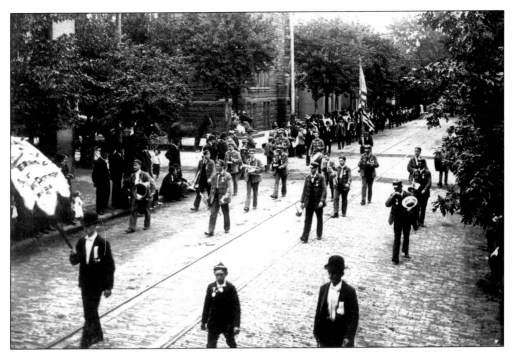

BRINGING UP THE REAR. More members of Patton's Band bring up the rear of their group, as they pass the Hamline M.E. Church on North 4th Street. Note the abundance of trees along the streets in those days. (PLSJOC.)

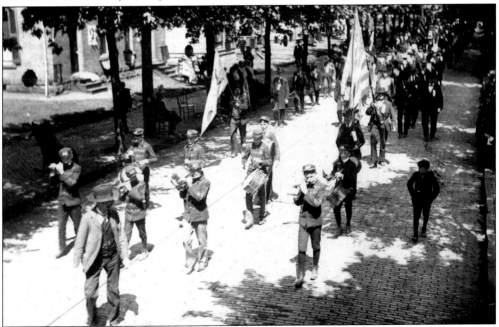

FIFE AND DRUM CORPS. Young boys march in the Centennial Parade as a Fife and Drum Corps, marching on North 4th Street in the residential area. Parade onlookers are less numerous than in the downtown business area; some people have brought chairs out to curbside expecting a long parade. (PLSJOC.)

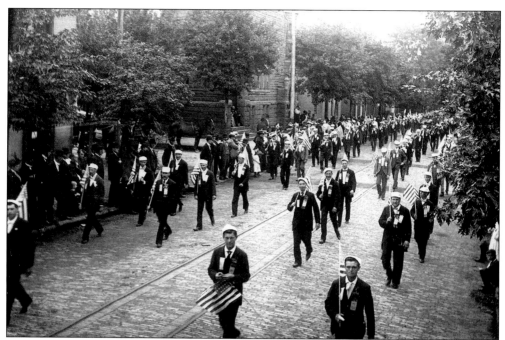

FRATERNAL PATRIOTS. A fraternal organization marches in the Centennial Parade, all carrying American flags. On an August day, with everyone dressed in black coats, how hot would it have been? (PLSJOC.)

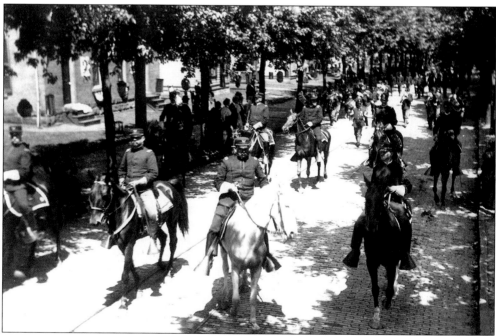

SOLDIERS ON HORSEBACK. An equestrian unit of former soldiers clops down the brick street in 1897, the sound of horse's hooves on the hard street making a distinctive sound. (PLSJOC.)

20

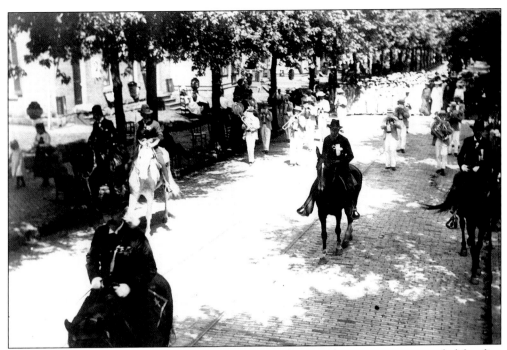

KEEPING IN STEP. A small band plays to keep the marchers in step, preceded by five horses. (PLSJOC.)

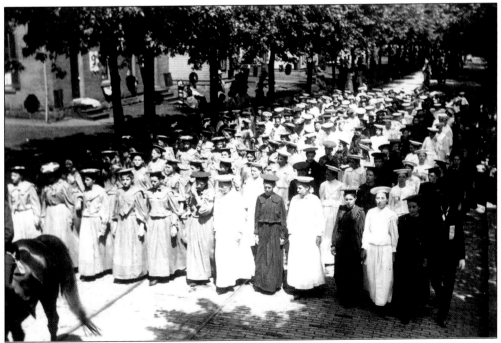

THE STEUBENVILLE FEMALE SEMINARY. These women represent the Steubenville Female Seminary, an institution formed in Steubenville in 1829; it closed the next year after the centennial. Over its life, the seminary graduated over 5,000 women from across the nation. (PLSJOC.)

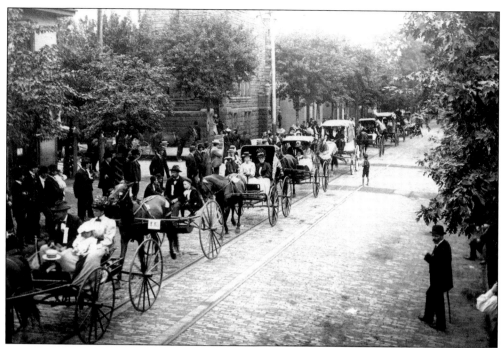

1897 Centennial Parade Elegance. A long row of horse-drawn carriages with well-dressed occupants proceeds down North 4th Street in an elegant line for the Centennial Parade. (PLSJOC.)

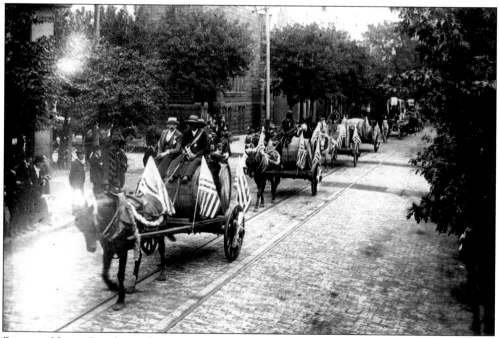

Sitting High. Four horse-drawn carts bring the riders, sitting atop large barrels, through the Centennial Parade. It would be of interest to know what is in the barrels! (PLSJOC.)

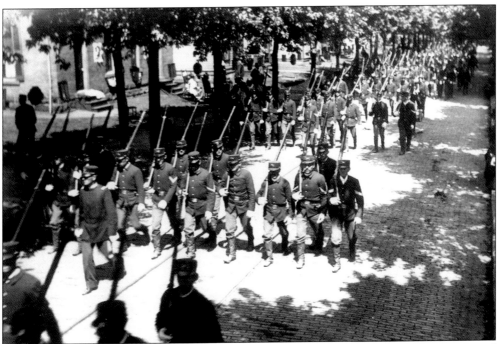

SOLDIERS MARCHING IN THE 1897 CENTENNIAL PARADE. Soldiers march in the Centennial Parade honoring Steubenville's 100th birthday. (PLSJOC.)

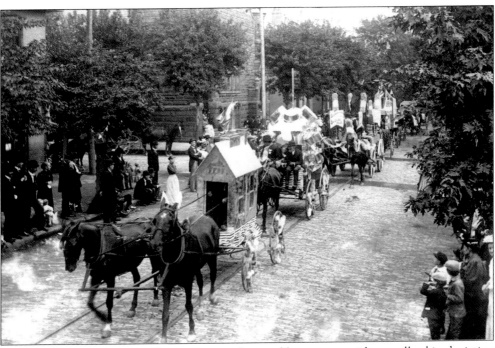

HONORING THE PIONEERS. The pioneers are honored by a wagon with a small cabin depicting life on the Ohio Frontier in the 1790s. (PLSJOC.)

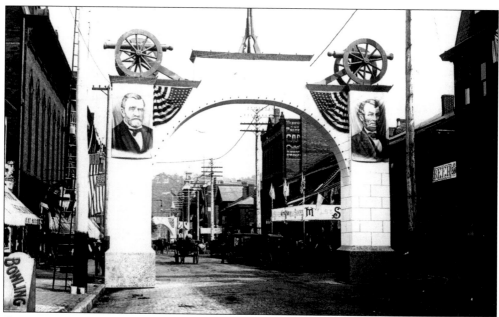

CENTENNIAL ARCH AT 6TH AND MARKET STREETS. This Centennial Arch was erected at the corner of 6th and Market Streets in downtown Steubenville. President and Civil War General Ulysses S. Grant and President Abraham Lincoln are honored on the arch with their portraits. Lincoln stopped in Steubenville in 1861 on the way to his inauguration and delivered a speech near the train depot. (PLSJOC.)

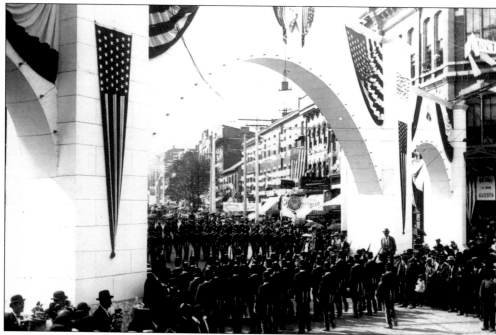

CENTENNIAL ARCH AT 4TH AND MARKET STREETS. The location of this Centennial Arch is at 4th and Market Streets. A large delegation of soldiers are making the turn at the corner, celebrating the 100th anniversary of the founding of Steubenville. (PLSJOC.)

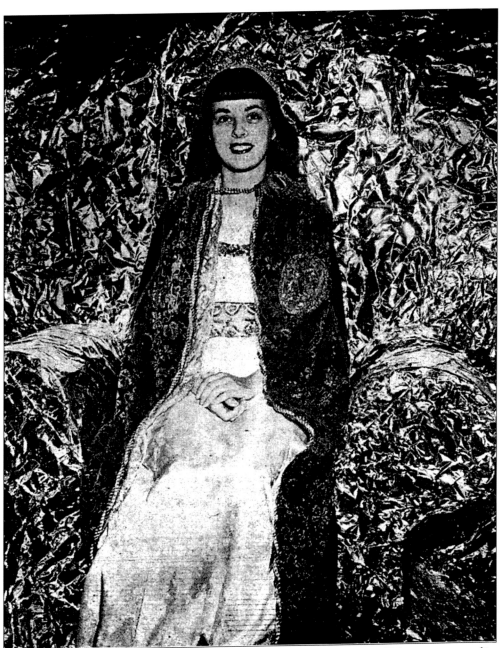

1947 SESQUICENTENNIAL QUEEN. In 1947, Steubenville celebrated the 150th anniversary of its founding, and Carolyn Schaffner, an 18-year-old city resident, was elected queen. She is sitting on her throne at Harding Stadium. Carolyn later became a fashion model and appeared on the cover of *Seventeen* magazine several times in the 1950s. In 1956, she was a member of the royal wedding party of Princess Grace and Prince Rainier of Monaco. It was reported in 1989 that she was residing in New York. (PLSJOC.)

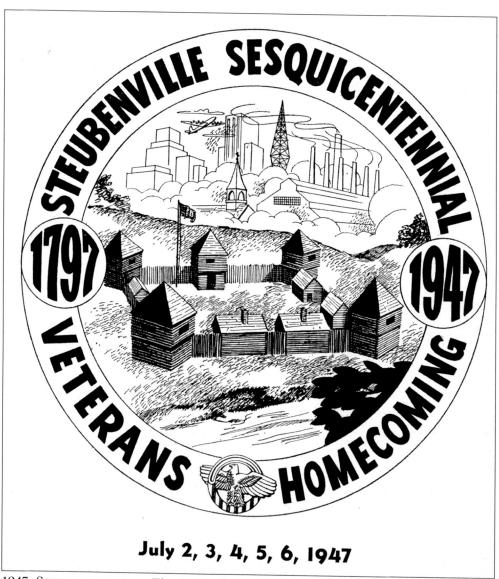

STEUBENVILLE SESQUICENTENNIAL
1797
1947
VETERANS HOMECOMING

July 2, 3, 4, 5, 6, 1947

1947 SESQUICENTENNIAL. The 1947 celebration of Steubenville's 150th anniversary was officially called the "Steubenville Sesquicentennial and Veterans' Homecoming 1797–1947" to honor all veterans, but especially the returning veterans of World War II. The climax took place from July 2–6, 1947, with a dramatic program at Harding Stadium titled, *Stockade to Steel.* The production was massive involving hundreds of people, with activities planned all over the city. (PLSJOC.)

Three

STREET SCENES 1846–2004 AND RAILROADS 1889–2004

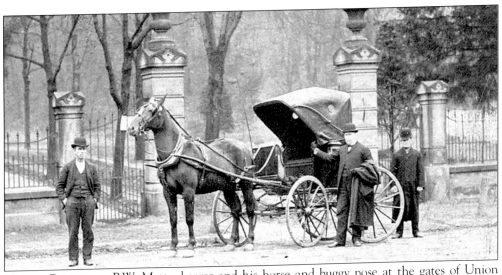

UNION CEMETERY. B.W. Mettenberger and his horse and buggy pose at the gates of Union Cemetery in 1896. The cemetery was established in 1854 with 600 initial burials coming from earlier downtown cemeteries. Today, Union Cemetery consists of 121 acres of beautifully landscaped grounds.

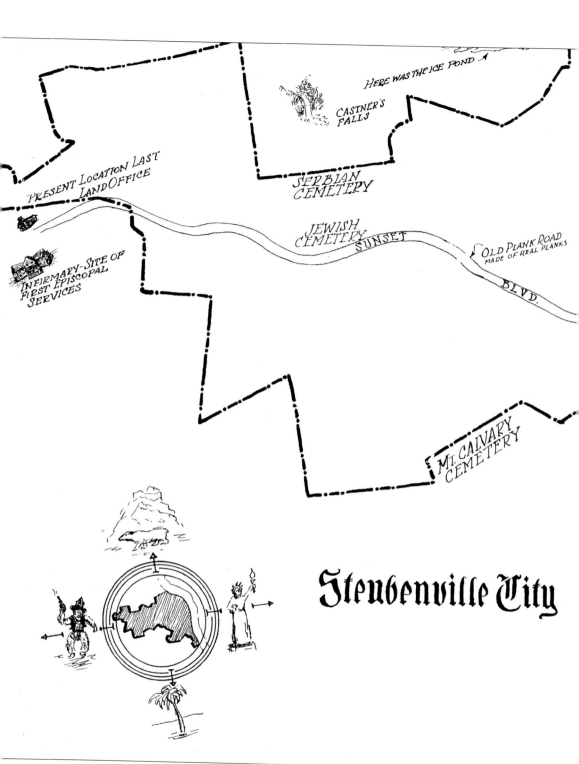

Steubenville City

STEUBENVILLE MAP DRAWING. This drawing was done for the 1947 Sesquicentennial Celebration and shows what the city would have looked like in its early days. Note the towns of Fisherville and Jacksonville that are now part of the City of Steubenville.

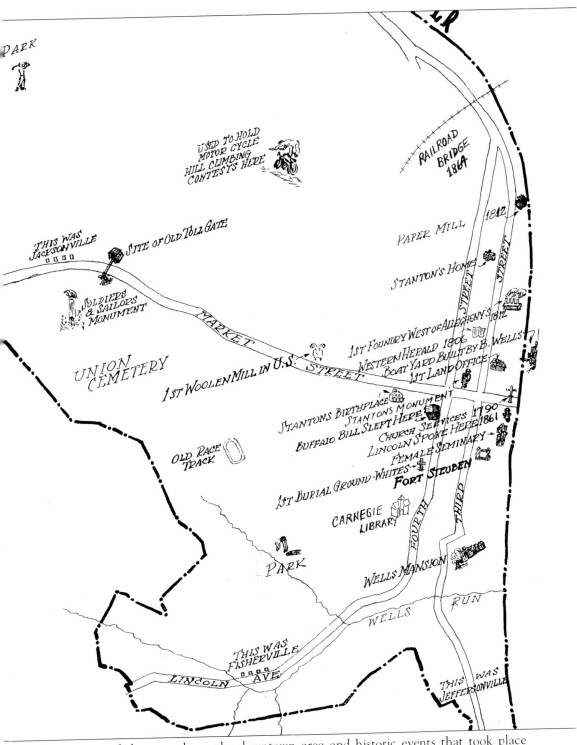

This portion of the map shows the downtown area and historic events that took place there. (PLSJOC.)

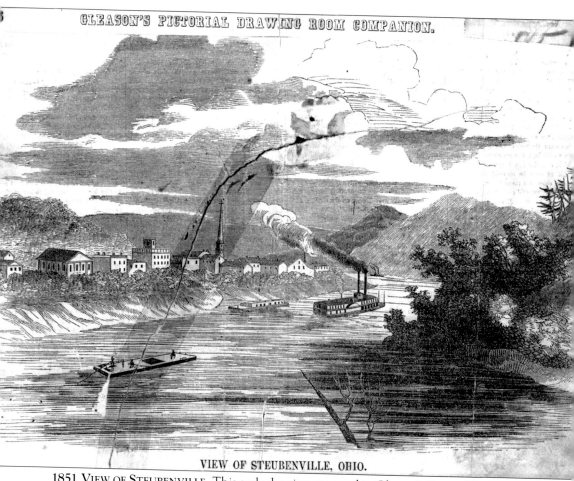

VIEW OF STEUBENVILLE, OHIO.

1851 VIEW OF STEUBENVILLE. This early drawing appeared in *Gleason's Pictorial Drawing Room Companion*, which describes the city as a "lively little place" and calls the scenery of the area "the fairest kind upon this fairest of rivers." In talking about the naming of the city, it refers to "Baron Steuben" and compliments his service in the American Revolution. Note the steamboat on the Ohio River and a flatboat docked at the Market Street Wharf. The buildings of the Steubenville Female Seminary are along the river bank. (PLSJOC.)

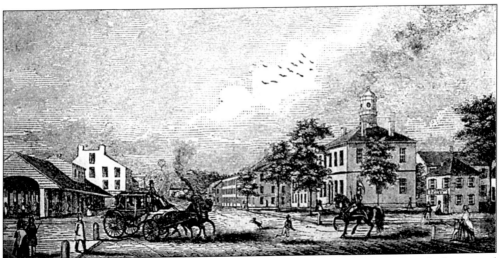

1846 VIEW OF MARKET STREET. This early drawing shows Market Street, with the second Jefferson County Court House, constructed in 1809, on the right. The building on the left front is the city building and marketplace area. (PLSJOC.)

1865 PHOTOGRAPH OF MARKET STREET. Taken from 4th and Market Streets, this photograph looks toward the hills of West Virginia, which had just been separated from Virginia in 1863. The city marketplace is in the center of the photograph. (PLSJOC.)

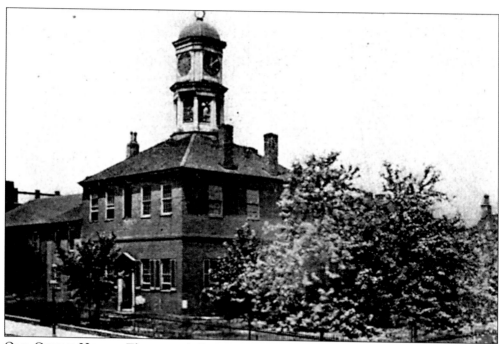

OLD COURT HOUSE. The second Court House replaced the original log structure. This new structure cost $2,260.49—plus one half-cent! It was a two-story brick building with a cupola. (PLSJOC.)

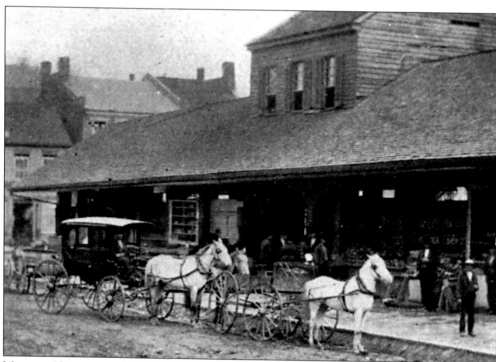

MARKET HOUSE AND COUNCIL CHAMBERS. This 1850s photograph shows the city marketplace and city offices, which stood across from the county court house. (PLSJOC.)

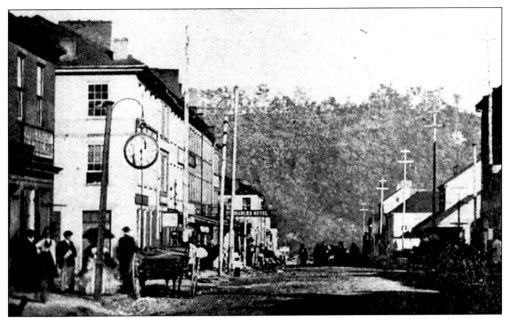

MARKET STREET SCENE 1865–70. Commercial development continued after the Civil War, and Steubenville was one of Ohio's largest cities. Street signs began to appear for businesses—note the large watch at the curb advertising a watch and clock shop. (PLSJOC.)

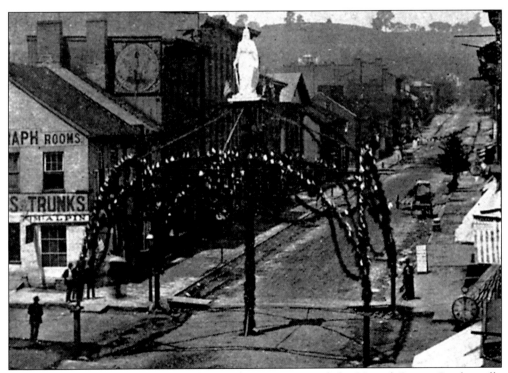

CENTENNIAL ARCH. Celebrating the 100th anniversary of the United States, Steubenville erected an arch at 4th and Market Streets on July 4, 1876. (PLSJOC.)

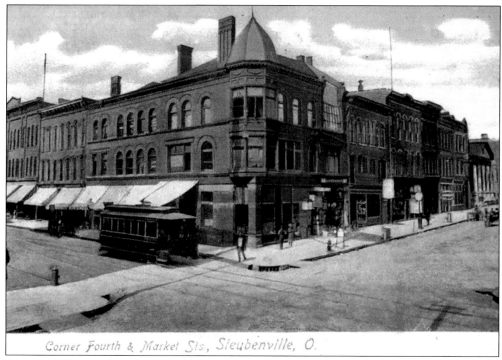

Corner Fourth & Market Sts, Steubenville, O.

4TH AND MARKET STREETS. This 1908 postcard shows the downtown area as it developed with new Victorian buildings. Curbs and sidewalks and a streetcar line enhance the street scene. Note the awnings covering the sidewalks. (PLSJOC.)

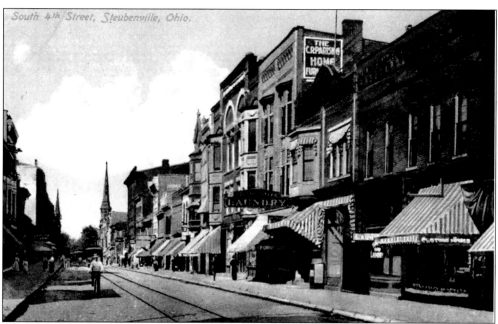

South 4th Street, Steubenville, Ohio.

SOUTH 4TH STREET. This postcard shows South 4th Street from Market Street. The Steubenville Steam Laundry, seen in this photograph, was located at 142 South 4th Street in 1908. (PLSJOC.)

34

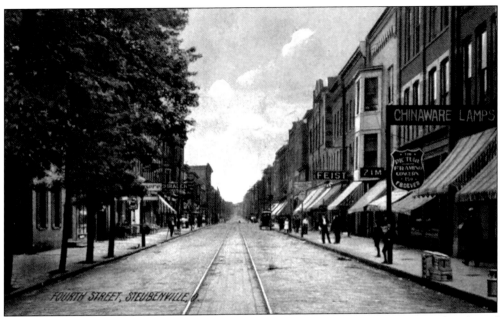

NORTH 4TH STREET. This view of North 4th Street shows the art of the postcard maker of the early 1900s. In reality, this street was lined by poles for telegraph, telephone, and electrical wires; all of which were removed from the photograph for a more pleasant street scene. Note the portions of poles still visible along the curb line of the street. (PLSJOC.)

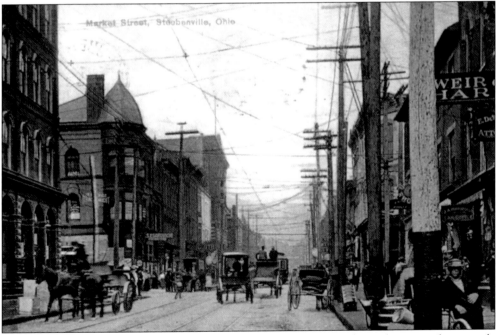

MARKET STREET. This view west on Market Street near 4th Street shows the city with its tangle of wires and poles all visible in the postcard. Even with brick paved streets, curbs and sidewalks, and streetcar lines, the common transportation in 1908 was still horse-drawn vehicles—and one bicycle. (PLSJOC.)

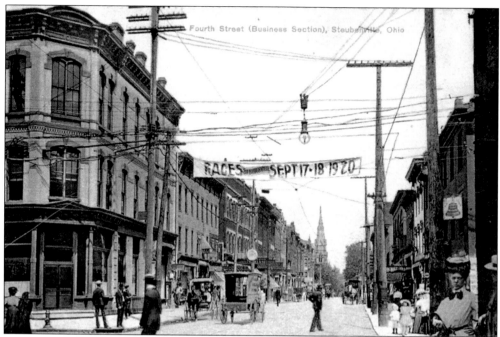

4TH STREET. This corner of 4th Street shows a banner advertising the Steubenville "Races Sept 17–18 1920." Note the street light hanging over the middle of the intersection with a large bulb to illuminate the street. (PLSJOC.)

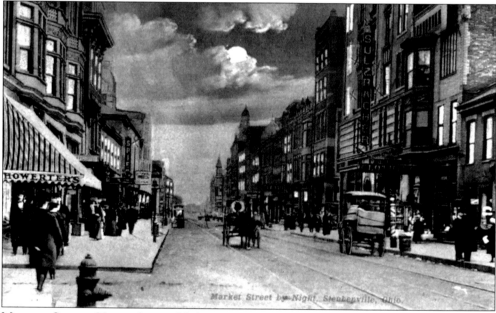

MARKET STREET NIGHT SCENE. Night scenes were popular postcards in the early 1900s. The photographer would take a daylight photograph, then an artist would carefully paint yellow in the windows, darken the sky and add a moon. In this photograph, Sulzbacher's Store is located between 4th and 5th Streets. By 1897, the store employed as many as 40 clerks on 3 floors of operation. (PLSJOC.)

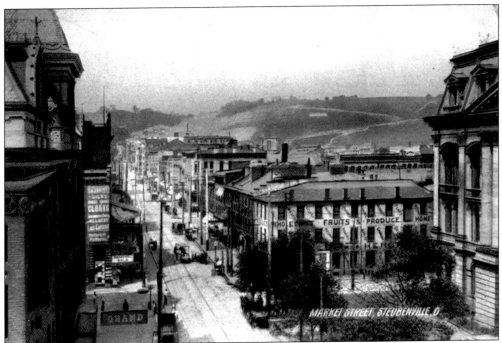

1874 Jefferson County Court House on Market Street. This 1900 photograph shows the 1874 Jefferson County Court House on the right and the City Hall on the left. In the distance, work has begun on converting the hilltops west of the downtown into neighborhoods for the growing population. (PLSJOC.)

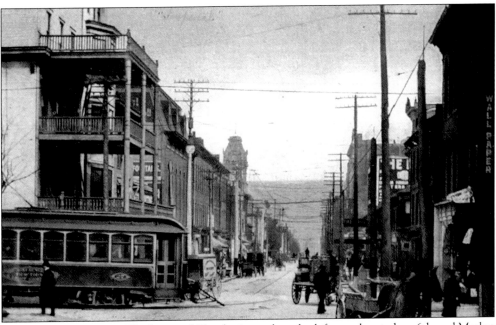

The Imperial Hotel. The Imperial Hotel, pictured on the left, was located on 6th and Market Streets. It was a popular hotel for train passengers, as it was across the street from the Depot. Note the streetcar with the horse-drawn vehicles. (PLSJOC.)

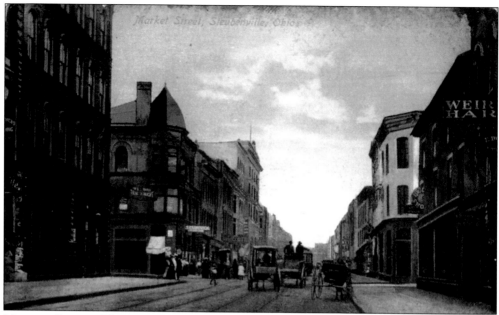

MARKET STREET. This 1909 postcard photograph of Market Street looking west at 4th Street has been carefully cleaned by the photographer of anything on the sidewalk or in the air. Postcards were common means of communication in this era, and people developed large collections of town photographs. (PLSJOC.)

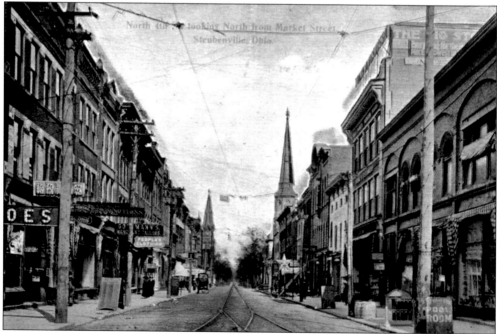

GOTTMANN MERCHANT TAILORS. In 1913, Gottmann Merchant Tailors was located at 127 North 4th Street and shared the commercial street with a dentist, a notions store, and a pool room. Note that the streetcar tracks divide to allow trolleys to pass each other on the one-track line. (PLSJOC.)

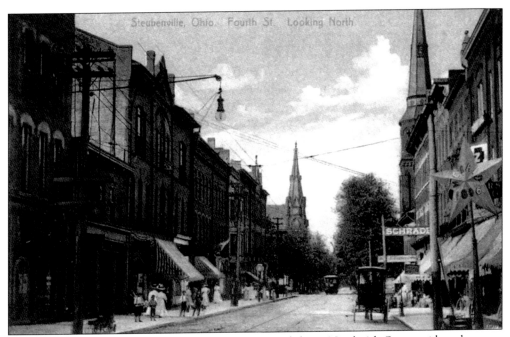

NORTH 4TH STREET. The street scene on this postcard shows North 4th Street midway between Market Street and Washington Street. Note the star-shaped sign on the right that is advertising the *Herald-Star* newspaper, which started in 1806 and still operates today. (PLSJOC.)

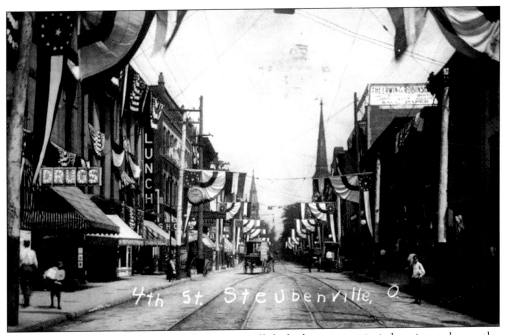

PATRIOTIC NORTH 4TH STREET. The street is all decked out in patriotic bunting to honor the dedication of the Edwin M. Stanton statue at the Court House in 1911. Huge crowds watched the dedication of the statue honoring Steubenville's native son. (PLSJOC.)

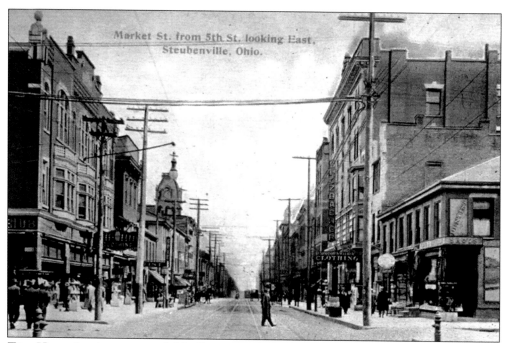

THE HUB. At the corner of 5th Street is The Hub, a favorite shopping destination for Steubenville shoppers. To the left is the original store building after its 1904 opening as a complete department store. The Court House tower is in the distance, looking east on Market Street. (PLSJOC.)

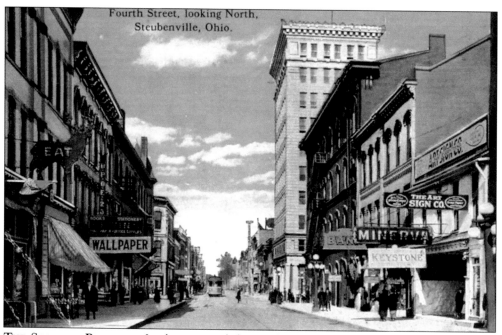

THE SINCLAIR BUILDING. Looking toward the Market Street corner, this postcard shows the new Sinclair Building, the tall building on the right. Built in 1915, the bank building was later expanded and was the home of the Union Savings and Trust Company. (PLSJOC.)

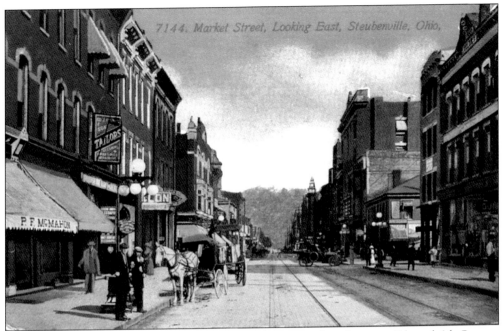

MARKET STREET. This 1908 postcard views Market Street from between 5th and 6th Streets, looking east. One auto is visible, sharing the street with horse-drawn vehicles. (PLSJOC.)

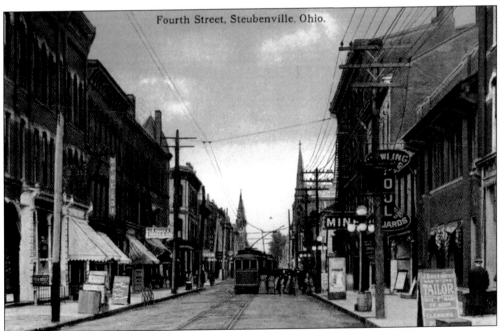

Fourth Street, Steubenville, Ohio.

DOWNTOWN. In 1908, the downtown area was looking more commercial as older buildings were replaced by three-story masonry structures with offices and storefronts. Bowling and billiards were offered in the building on the right. (PLSJOC.)

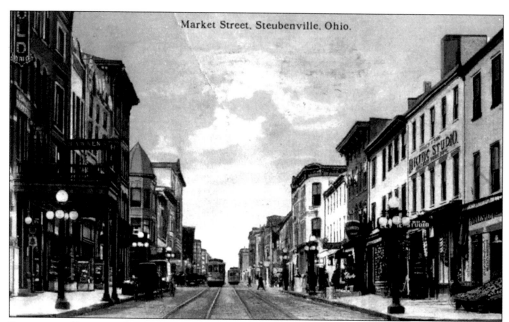

Market Street, Steubenville, Ohio.

JEFFERSON COUNTY COURT HOUSE. This 1910 downtown street scene is Market Street, in front of the Jefferson County Court House. The double-track streetcar line runs in the street, which has a new look with electric street lighting and sidewalk-mounted decorative fixtures with round globes. (PLSJOC.)

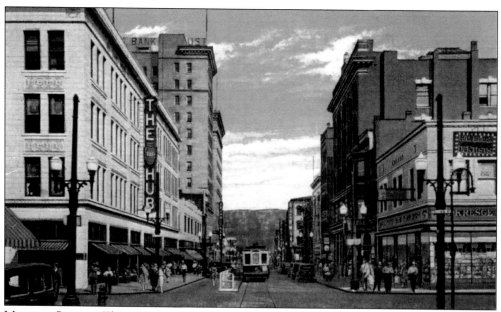

MARKET STREET. This 1930 postcard shows new street lighting mounted by side brackets on the steel streetcar wire supports. The scene is at 5th Street, with the S.S. Kresge Co. on the right, and the renovated and enlarged Hub Department Store on the left, complete with its fourth floor and white terra cotta front. The Hub continued operations under that name until 1978 when it became Good's Department Store, which closed in 1980. The vacant building was demolished in 1993 and has been replaced with a chain drug store and parking lot. (PLSJOC.)

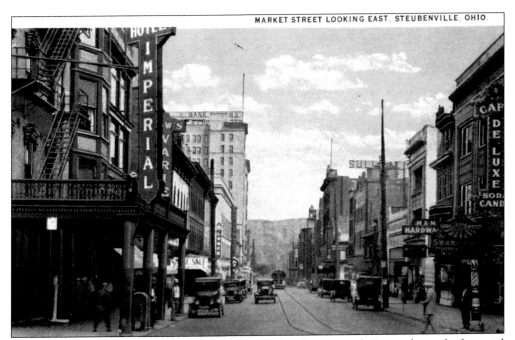

MARKET STREET IN 1922. This 1922 scene of Market Street at 6th Street shows the Imperial Hotel to the left and M. & M. Hardware Co. on the right, next to the Café De Luxe and Swan-Bower. More autos are using the street, with not a horse in sight. (PLSJOC.)

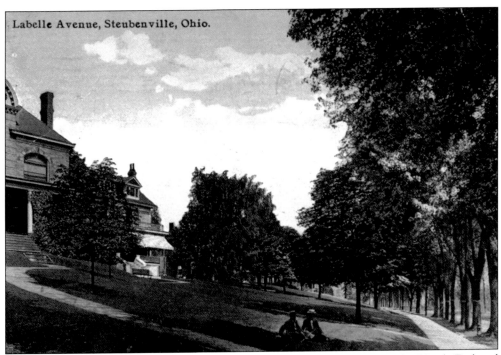

LABELLE AVENUE. In 1911, Labelle Avenue ran along the Ohio River in the North End and was a tree-lined street with large homes on the terrace. The street is now gone, replaced by the State Route 7 relocation completed in 1962. (PLSJOC.)

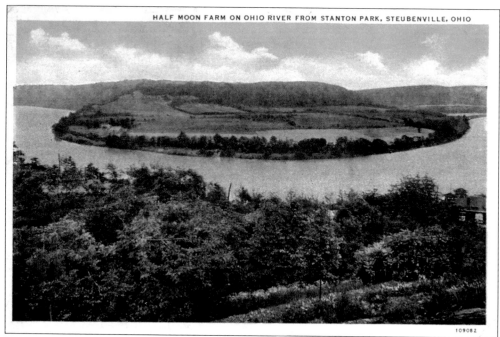

HALF MOON FARM ON OHIO RIVER FROM STANTON PARK, STEUBENVILLE, OHIO

HALF MOON FARM. Just north of Steubenville, the Ohio River makes a sharp bend around the Half Moon Farm in West Virginia. On the Ohio River shore was Stanton Park, an amusement "trolley park." Today, that is the site of the S.R. 7 / U.S. 22 interchange, and across the river is now the Half Moon Industrial Park. (PLSJOC.)

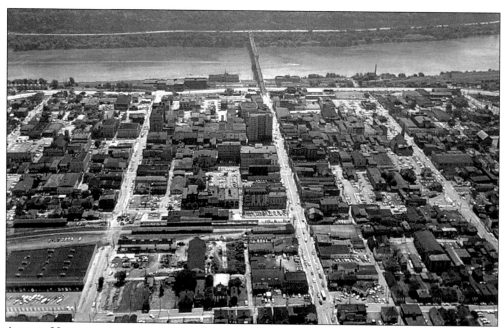

AERIAL VIEW OF DOWNTOWN STEUBENVILLE. This aerial view of downtown Steubenville in the 1960s shows the Market Street Bridge crossing the Ohio River to West Virginia. To the left is Washington Street, and to the right is Adams Street. (PLSJOC.)

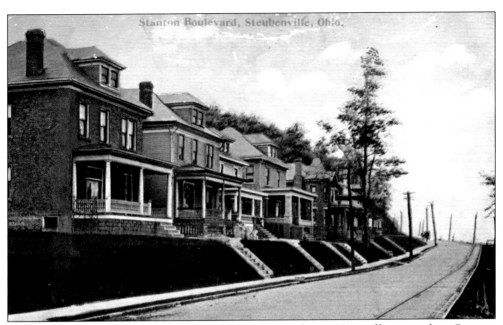

STANTON BOULEVARD. Entering the city from the north in 1911, traffic entered on Stanton Boulevard, a street facing the Ohio River. Large American Four-Square homes graced the street, with streetcar tracks running on the edge of the street to conserve the precious space along the river. (PLSJOC.)

Stanton Boulevard by Moonlight, Steubenville, Ohio.

STANTON BOULEVARD AT NIGHT. A trick of early postcard makers creating a night scene was to photograph the scene during the day, darken the photograph, highlight sidewalks and porch posts, then place a white aspirin tablet on the photograph for the moon, and re-photograph the scene. The result—a popular night scene. (PLSJOC.)

45

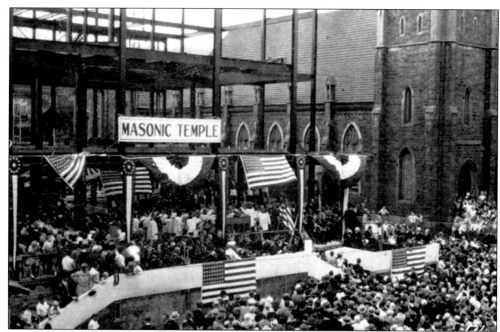

MASONIC TEMPLE. Masonic leaders from Ohio gathered in Steubenville on September 21, 1930, to lay the cornerstone for the new Temple on North 4th Street. The Westminster Presbyterian Church is to the right. (PLSJOC.)

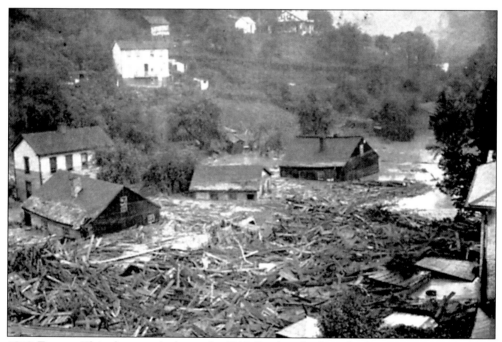

1913 FLOOD. This photograph shows the 1913 flood in the Lincoln Avenue area, as the Ohio River backed up the valley from its 42.6 foot crest. This flood devastated most of Ohio. Much of Steubenville sits high above the riverbank; in the 1936 flood, Steubenville was the only city with a bridge open to traffic all along the river. (PLSJOC.)

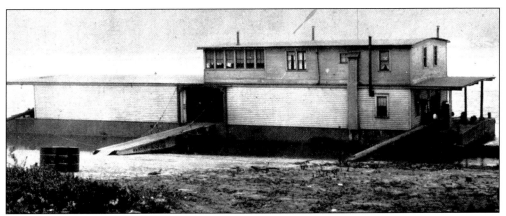

WHARF BOAT. Wharf boats were common on the Ohio River prior to about 1940. This one is docked at the foot of Market Street on the wharf constructed for that purpose in the 19th century. (PLSJOC.)

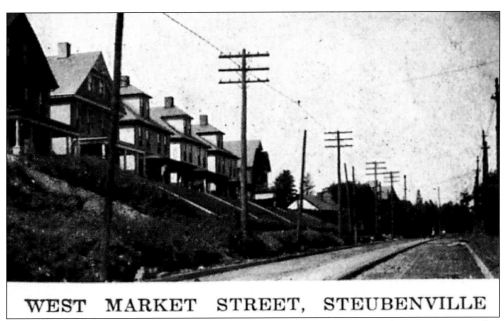

WEST MARKET STREET, STEUBENVILLE

WEST MARKET STREET. At the top of the Market Street hill, the street became West Market Street and connected to the West End. The street was expanded in the 1960s and rerouted up Washington Street, leading to the renaming of the street to Sunset Boulevard, a continuation of the street to the west. (PLSJOC.)

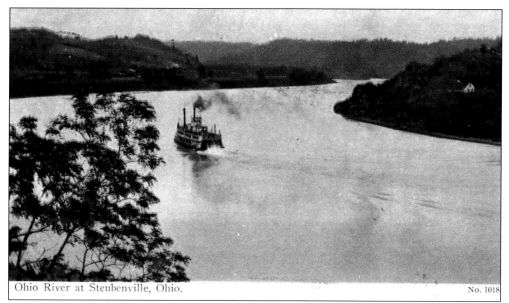

Ohio River at Steubenville, Ohio. No. 1018

OHIO RIVER. This 1907 postcard shows a steamboat rounding the Half Moon north of Steubenville. Steamboats enjoyed a century and a half of active use on the Ohio River before scheduled passenger service and towboats were replaced by diesel towboats. (PLSJOC.)

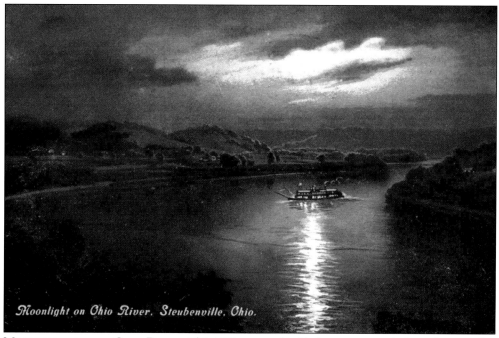

Moonlight on Ohio River. Steubenville. Ohio.

MOONLIGHT ON THE OHIO RIVER. This 1911 postcard is likely more artwork than photography. At the same location as the above postcard, it isn't likely for a steamboat to operate sideways on the river, but to allow it to be seen in the "moonlight," some artistic license must have been used. (PLSJOC.)

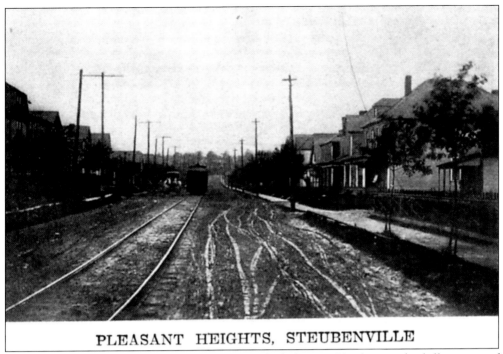

PLEASANT HEIGHTS, STEUBENVILLE

PLEASANT HEIGHTS. In 1904, the neighborhood of Pleasant Heights on the hilltop west of the downtown was new, as evidenced by the unpaved streets. The streetcar had a difficult time making the climb to the new neighborhood. (PLSJOC.)

SOUTH 4TH STREET. This 1912 scene of South 4th Street is near the corner with Slack Street. A Victorian house sits at the corner, and the tower of the 1870 Grant School is in the distance. The stone wall of the Carnegie Library is visible to the left. (PLSJOC.)

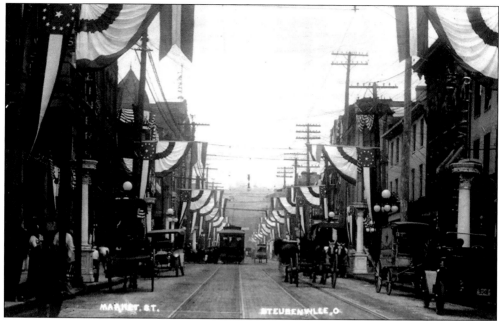

MARKET STREET TRANSPORTATION. This view of Market Street shows a variety of transportation modes. There are horse-drawn delivery wagons, freight carts, buggies, motor vehicles, and a streetcar, trying to make its way through the assortment. Reiner's Department Store is on the left. (PLSJOC.)

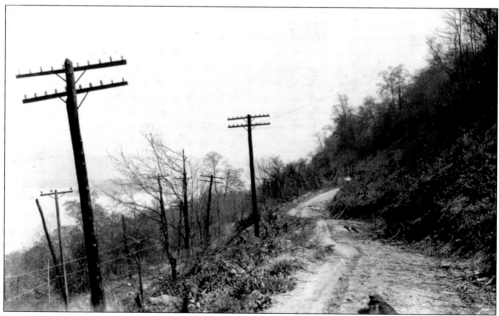

RIVER ROAD. The Ohio River may have been the highway for boats, but traveling by land along the river was difficult. This photograph is Inter-County Highway No. 7, now State Route 7, north of Steubenville before improvements were made. (ODOT.)

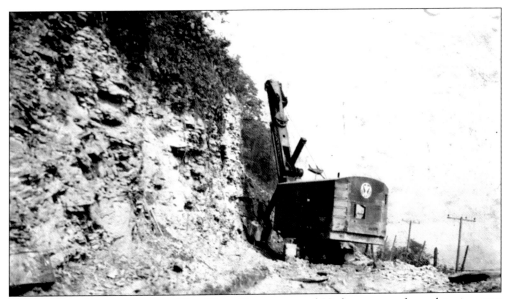

RIVER ROAD IMPROVEMENTS. The Ohio Department of Highways was formed to improve connecting roads for motor vehicle use. Here is a Bay City Gas Shovel in 1926 creating a path for the Ohio River road. By 1935, an improved two-lane road extended through Steubenville along the river. (ODOT.)

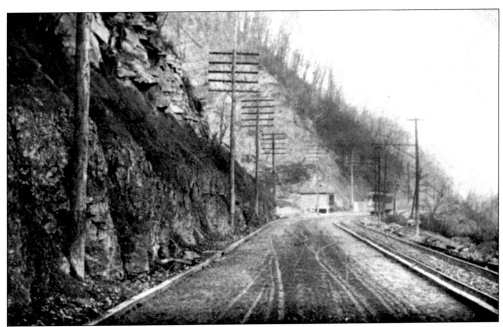

STATE ROUTE 7. A river road was completed on a shelf created from the face of the hillside. Here, the road shares the space with streetcar tracks and power and telegraph lines. Rock slides are common along these roads, even today. (PLSJOC.)

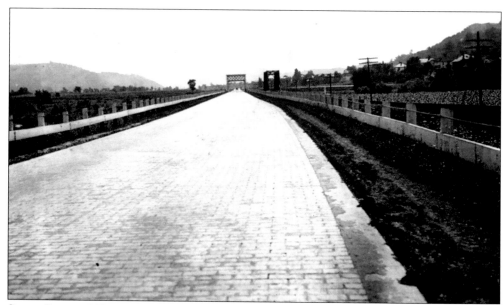

STATE ROUTE 7 RECONSTRUCTION. By the time of this 1933 reconstruction, the highway was known as State Route 7. The mud and gravel road was rebuilt with concrete, or in this case brick with a concrete edge. Here the road crosses the river plain north of Rayland approaching the Short Creek Bridge. Between the years of 1950–1975, State Route 7 was reconstructed to a four-lane highway through Steubenville. Today, the new highway is to the left, and this roadway remains as an access road for the interchange. (ODOT.)

STATE ROUTE 43. Highways radiating into the county from Steubenville were also the task of the Ohio Department of Highways. In 1933, Inter-County Highway 75 became State Route 43, an all-weather concrete road with gravel berms. The highway travels northwest from Steubenville towards the Village of Richmond. (ODOT.)

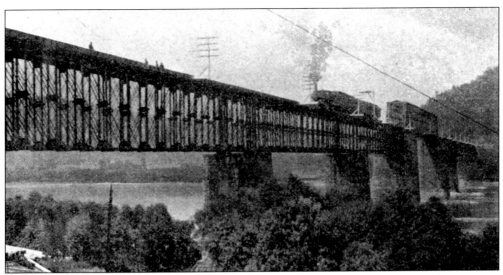

FIRST RAILROAD BRIDGE. Construction for the first railroad bridge to cross the Ohio River at Steubenville began in 1857. Interrupted by jurisdictional disputes and the Civil War, work began again in 1862 with Jacob Hays Linville as engineer of the long-span truss bridge. It was a form of Whipple truss with ornate cylindrical posts of cast iron, and with other members of wrought iron. The bridge opened to rail traffic in 1865. It was upgraded in 1889 and 1909 and completely replaced in 1926. Today, one pier of the original span remains to support the current bridge, in the median of State Route 7 on the Steubenville side of the bridge. (PLSJOC.)

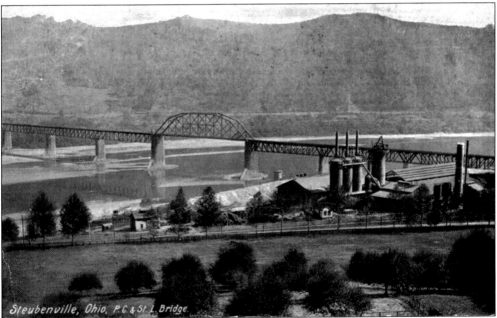

PC&STL RAILROAD BRIDGE. The Pittsburgh, Cincinnati, and St. Louis Railroad Bridge was completed in 1889 using the same piers as the previous bridge. It was needed to accommodate the heavier locomotives and loads of trains of the day. The main span was an arched simple truss. The Pennsylvania Railroad improved the line in 1909 and replaced the approaches to the bridge. (PLSJOC.)

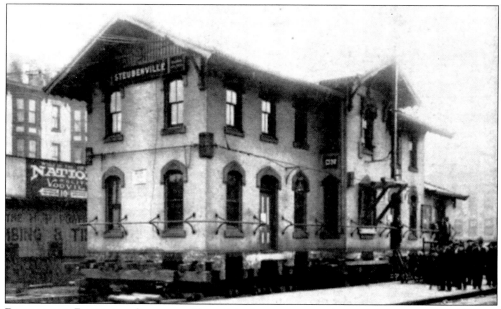

PANHANDLE RAILROAD STATION. The original passenger station was constructed in 1879 on the Panhandle Line to serve passengers at 6th and Market Streets. It replaced various depots that handled early traffic. By 1911, the line had been acquired by the Pennsylvania Railroad who moved the first depot and constructed a modern station that served until passenger traffic ended in 1970. (PLSJOC.)

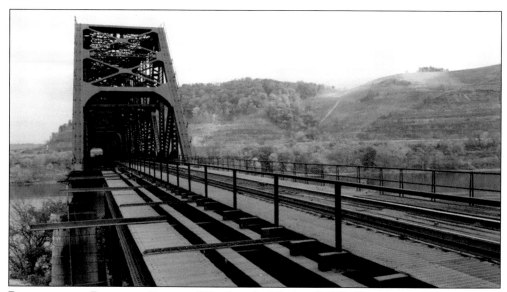

PENNSYLVANIA RAILROAD BRIDGE. "The Standard Railroad of the World" operated a main line through Steubenville for 109 years. Its passenger train, *The Spirit of St. Louis,* passed through the city in the wee hours of the night on its way from New York to St. Louis. The powerful steam locomotives pulled the coaches, sleepers, and diners across the bridge to the Steubenville Depot at 6th and Market Streets, connecting the city to the rest of America. Service ended in 1970, as the Penn Central ended all passenger trains west of Harrisburg. (Photograph by Ron Smith.)

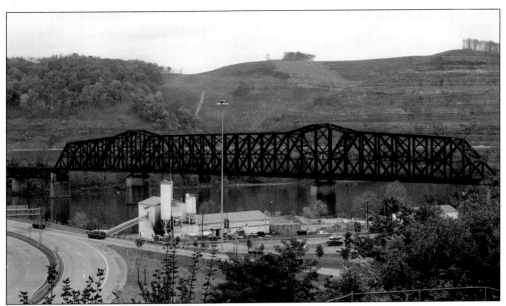

NS RAILROAD BRIDGE. The Norfolk Southern Railroad Bridge is a massive structure that was acquired from Conrail. The current span was constructed in 1926 by the Pennsylvania Railroad for its Panhandle Division, using approach spans from 1909. The 8,000 ton bridge was constructed around the previous bridge, not interrupting rail traffic. Originally a two-track span, today the bridge is part of the River Division servicing area industry. (Photograph by Ron Smith.)

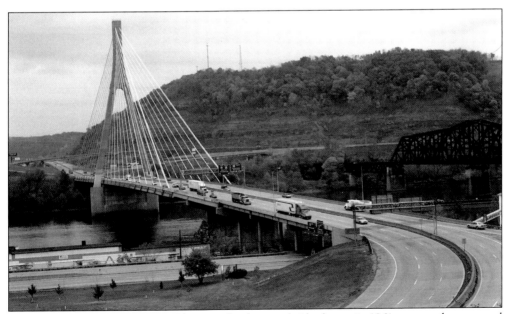

VETERANS MEMORIAL BRIDGE. Planning for this new bridge began in 1961 to carry the proposed U.S. Route 22 expressway across the Ohio River at Steubenville. The bridge opened on May 5, 1990, as a six-lane, cable-stayed span; the sixth such design in the U.S., It was designed by the Michael Baker Co. of Beaver, Pennsylvania, and constructed by several different contracts. The total cost of the entire project was more than $70 million. (Photograph by Ron Smith.)

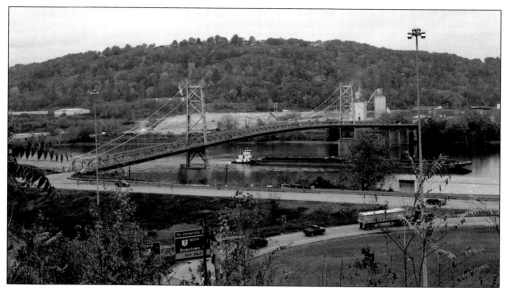

FORT STEUBEN BRIDGE. Constructed by the Dravo Contracting Co. of Pittsburgh for the Steubenville-Weirton Bridge Co., this bridge opened in 1928. It remained a toll span until 1947, when the toll was removed and ownership transferred to the State of Ohio. This suspension bridge was the second in a series of bridges constructed across the Ohio River by Dravo; the first being at Portsmouth, Ohio. Improvements were made in 1956 and 1994 to the approaches. The span carried U.S. Route 22 across the river until 1990. (Photograph by Ron Smith.)

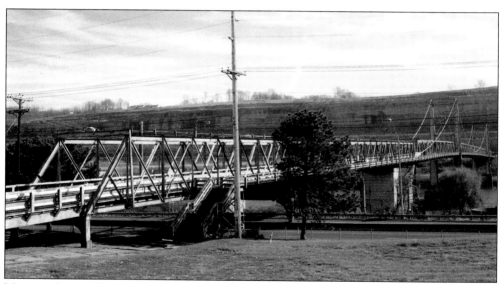

MARKET STREET BRIDGE. Designed by E.K. Morse and constructed by the Ohio Steel Erection Co., this bridge opened in 1905 to connect Steubenville with the steel mills in Follansbee, West Virginia. Originally used by interurban streetcars, automobiles also used the wooden deck. The State of West Virginia purchased the bridge in 1941 and removed the tolls in 1953. Young bridge engineer David B. Steinman (1886–1960) was hired to examine the bridge in 1922 to repair a broken chord on the span, with further reconstruction performed on the span in 1940, 1953, and 1982. Steinman was later the engineer for the Mackinac Bridge in Michigan. (Photograph by Ron Smith.)

Four

CHURCHES

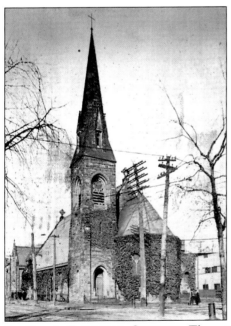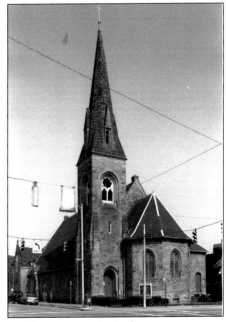

ST. PAUL'S EPISCOPAL CHURCH. These two photographs are a study in how street scenes changed from 1910 (on the left) to current day (on the right). Notice how streetcar tracks, trees, and telegraph poles have been replaced by traffic lights and painted cross walks, while the church building remains unchanged. The low Early English Gothic building was opened in 1880, replacing an 1833 structure occupied by the first denomination to hold regular services in Steubenville. The Reverend Joseph Doddridge began holding services in 1792. (PLSJOC.)

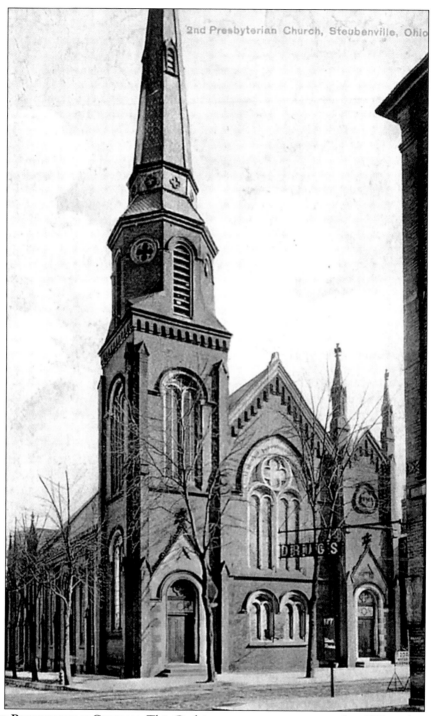

SECOND PRESBYTERIAN CHURCH. This Gothic structure was constructed in 1871 at the corner of 4th and Washington Streets. The congregation merged with another church in 1911, and the building was demolished as the site of the Fort Steuben Hotel in 1920. (PLSJOC.)

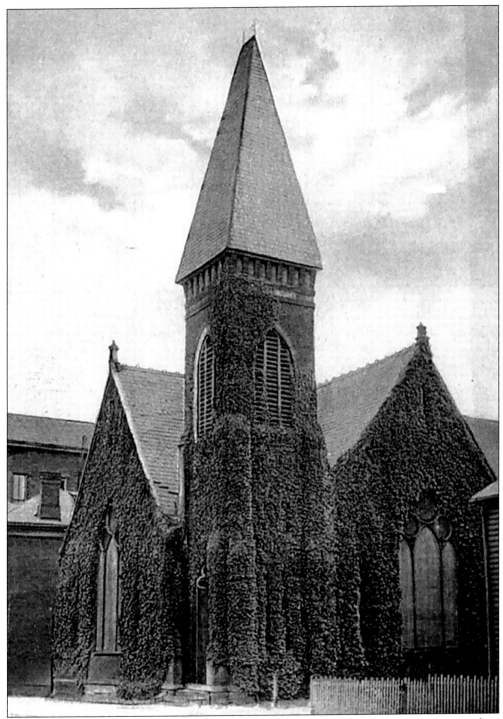

FIRST CONGREGATIONAL CHURCH. The ivy-covered church building was constructed in 1882 on Washington Street, with the congregation moving to Pleasant Heights in 1915. The church is typical of the architecture of the era, an overwhelming tower and steeple that often succumbed to removal or alteration if the church survived for a long time. (PLSJOC.)

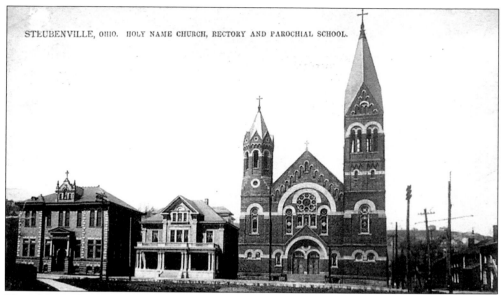

HOLY NAME CHURCH. Established in 1883, the church building was completed in 1900 at the corner of 5th and Slack Streets. The rectory and school sit beside the church. The school has been razed, but the building's façade has been retained with a park to the rear. The church structure has been completely reconstructed. (PLSJOC.)

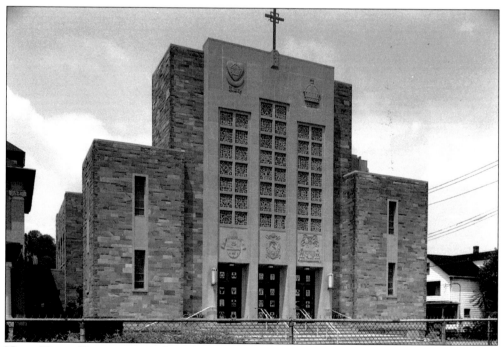

HOLY NAME CATHEDRAL. When the Diocese of Steubenville was established in 1944, Holy Name Church became Holy Name Cathedral. In 1953, the church was extensively renovated with the removal of the steeples and reconstruction of the dome to a flat roof. Over the door is the Crest of the Diocese of Steubenville, the Papal Coat of Arms, and the Crest of Bishop John King Mussio, the first bishop of the diocese (1945–1978). (Photograph by Ron Smith.)

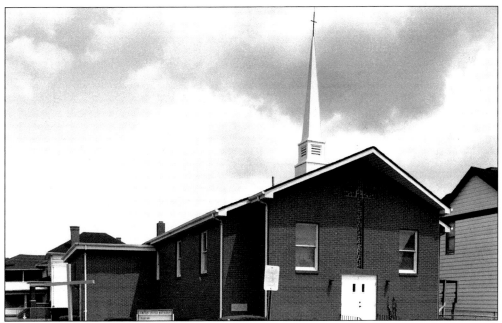

SIMPSON UNITED METHODIST CHURCH. Formed in 1873 from members of the African Methodist Episcopal congregation, this church had three other homes before moving to the current Slack Street location. The Colonial red brick building has a stained glass Roman Cross over the door. (Photograph by Ron Smith.)

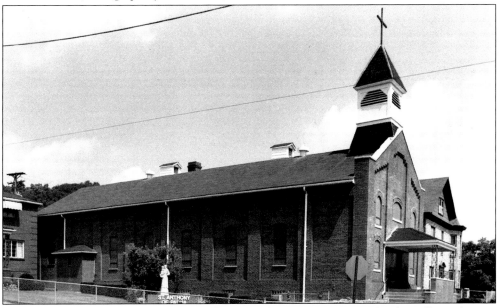

ST. ANTHONY CHURCH. With the influx of Italian immigrants to Steubenville, a distinct parish was formed in 1907 to serve the new population. In 1910, the building was constructed with a school, and a convent was added later. Guy and Angela Crocetti were married in the church in 1914, and in 1917, their son Dino Crocetti was born. He changed his name to "Dean Martin" and became Steubenville's most famous native son as an actor and entertainer. (Photograph by Ron Smith.)

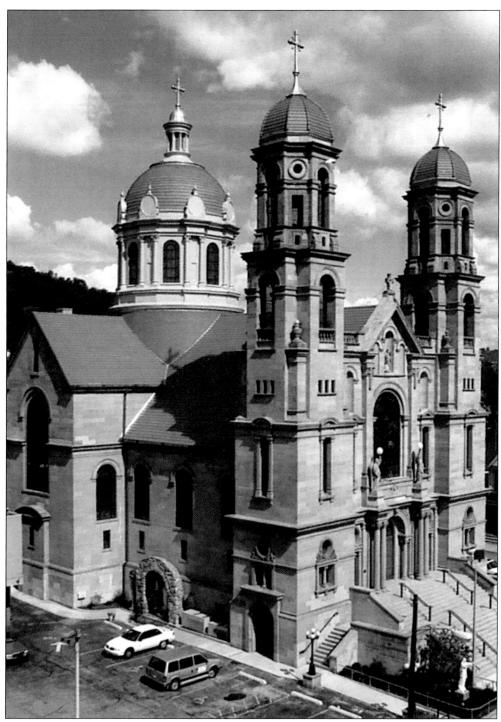

ST. PETER'S CHURCH. Constructed in 1907, the current French Renaissance-style church sits on property acquired in 1830 that has had two previous church buildings on it. Renovations were undertaken in 1957 and 1979. An exterior restoration was done in 1994 on the Amherst and stone and the towers that rise 95 feet from the ground. (PLSJOC.)

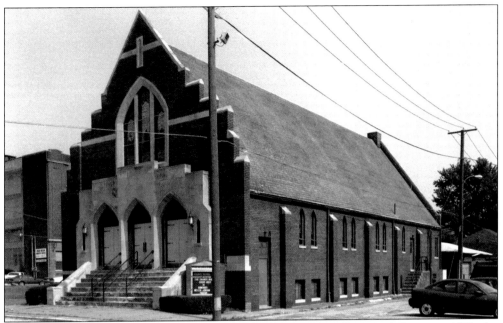

QUINN MEMORIAL AME CHURCH. Organized by Reverend William Paul Quinn in 1823, the first church was constructed at 3rd and South Streets in 1846. A new building was constructed at 5th and Washington Streets in 1878. The Ohio Power Company purchased that building in 1928 for its new downtown office building, and the church moved to North Street where this building was dedicated on Easter Sunday, 1930. (Photograph by Ron Smith.)

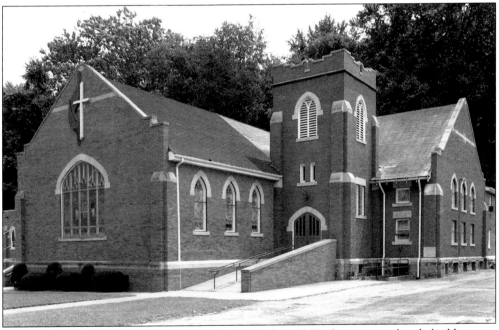

FINLEY UNITED METHODIST CHURCH. Established in 1868, the current church building was opened in 1912 with several additions and renovations changing the building to date. The name came from one of the area's first circuit rider preachers, J.B. Finley. (Photograph by Ron Smith.)

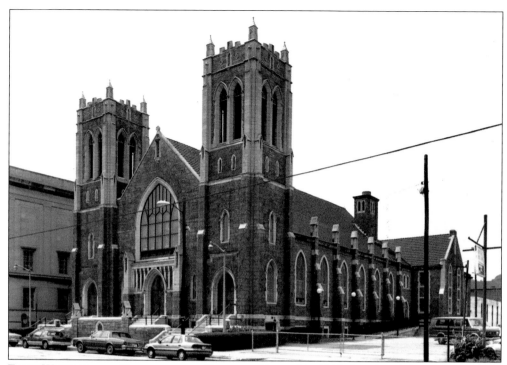

FIRST WESTMINSTER PRESBYTERIAN CHURCH. Opened in 1914, this church began as a merger of congregations. In 1989, First United Presbyterian Church and Westminster Presbyterian Church merged in this building. The cornerstone of the building was laid on September 30, 1913, with the Reverend W.A. "Billy" Sunday, the famous evangelist, giving the address. The two-towered building is utilized by the Civic Choral Society for its community concerts. (Photograph by Ron Smith.)

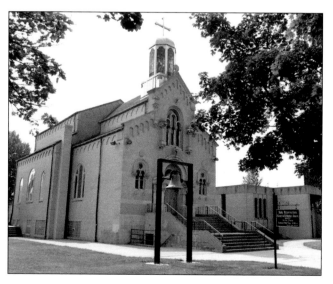

HOLY RESURRECTION SERBIAN EASTERN ORTHODOX CHURCH. Serbians came to Steubenville as early as 1890 to work in local industry. The Serbian Orthodox Church was started in 1906 and eventually operated a church in Mingo Junction. This building on 4th Street was constructed in 1948 to serve the congregation. (Photograph by Ron Smith.)

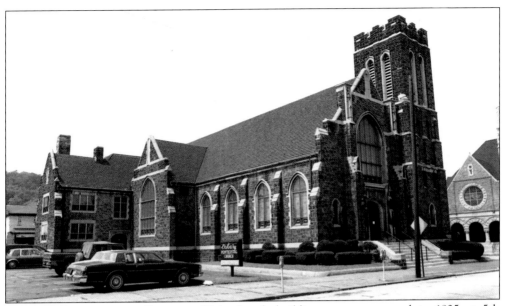

CALVARY PENTECOSTAL CHURCH. This church building was constructed in 1925 at 5th and North Streets as the First United Presbyterian Church. An earlier church began in 1810 in Steubenville and eventually located on the rear of this lot. The building was acquired by Calvary Pentecostal Church in 1989 as the First Presbyterian congregation merged with Westminster Church. (Photograph by Ron Smith.)

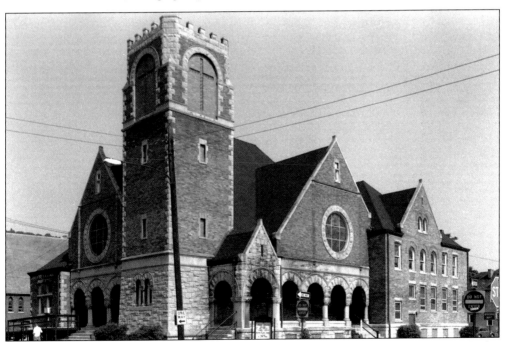

URBAN MISSION MINISTRIES. This building formerly housed the Fifth Street United Methodist Church and was opened in 1903. That church was organized in 1830 and was attended by Edwin M. Stanton's mother. The yellow brick building of Romanesque architecture was provided to the Urban Mission Ministries, a social agency, in 1989. (Photograph by Ron Smith.)

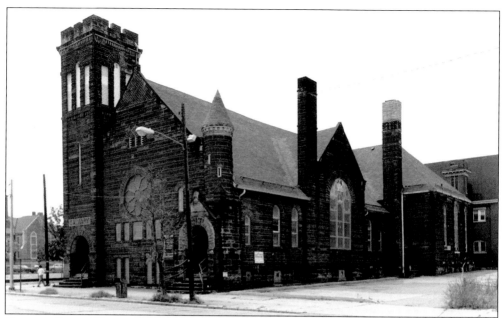

CALVARY-FIFTH UNITED METHODIST CHURCH. This dark stone structure has occupied the corner of 4th and North Streets since 1902. It came from the "Old First Church," from which four Methodist churches were formed. Edwin M. Stanton was a member of the First Church. (Photograph by Ron Smith.)

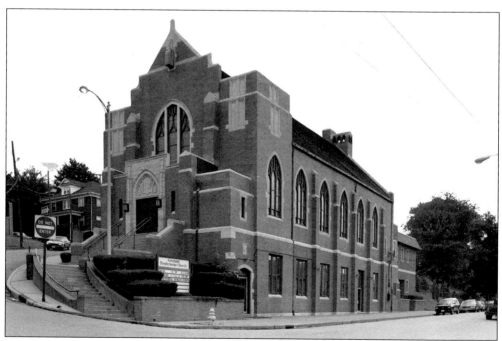

COVENANT PRESBYTERIAN CHURCH. This building was constructed in 1912 as the Second Presbyterian Church, to serve the new development of homes called LaBelleview overlooking downtown Steubenville. The Belleview Boulevard building was constructed in the "Akron" style of churches, with the name changing to Covenant in 1981. (Photograph by Ron Smith.)

First Christian Church, Disciples. Constructed in 1897, this Romanesque-Gothic structure is made of brick and sandstone. The 1914 pipe organ is one of the church instruments funded by Andrew Carnegie in the early 20th century and has the words "Soli Deo Gloria" inscribed on it, meaning "God alone be the Glory." (Photograph by Ron Smith.)

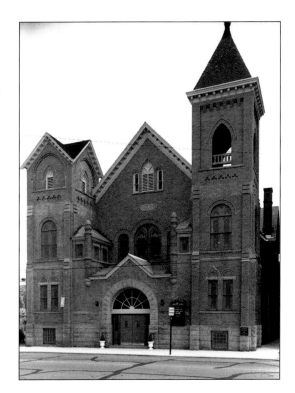

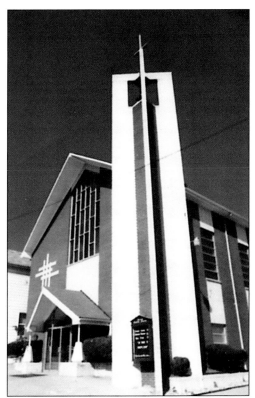

Second Baptist Church. Located on Adams Street, this is one of the newer downtown churches, constructed in 1970. The congregation formed in 1891 and worshiped in several locations before purchasing the Adams Street site in 1917. (PLSJOC.)

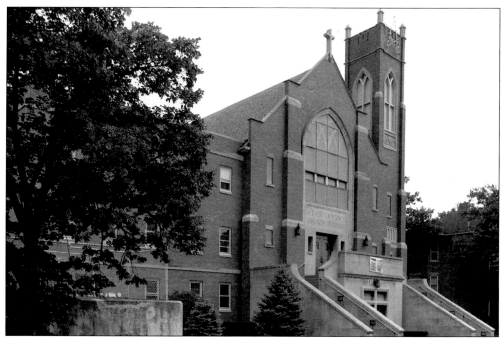

LaBelle View Church of Christ. Another church established to serve the residents of Steubenville's newest "suburbs" on the hilltops, this church provides a solid foundation with its steps and entryway. (Photograph by Ron Smith.)

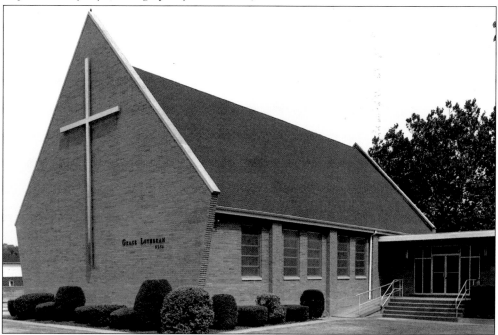

Grace Lutheran Church. By the 1920s, the Lutheran Church was looking to establish a church to serve the population of Steubenville moving west. A church building was completed in 1932 at Broadway and Sunset Boulevard, replaced by this building in 1958. (Photograph by Ron Smith.)

HOLY ROSARY CHURCH. Catholic Central High School moved to the western part of Steubenville in the 1950s as the diocese purchased land for a hospital and arena. Holy Rosary Church was another institution established to serve the post-World War II growth of the city. (Photograph by Ron Smith.)

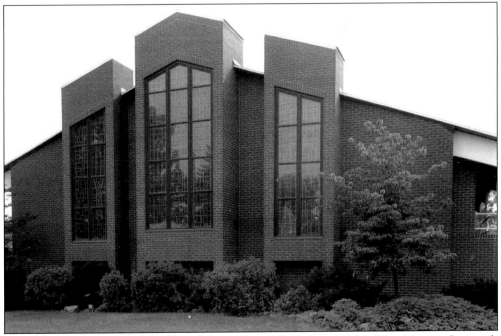

ST. PIUS THE X CATHOLIC CHURCH. Formed in 1955 by Bishop John King Mussio, the parish opened a school in 1958. In 1970, the school merged with the Catholic School in Wintersville to become Aquinas School. In 1985, the church underwent complete renovation. (Photograph by Ron Smith.)

St. Stephen's Episcopal Church. Formed in 1896, a church building was constructed at 5th and Logan Streets in downtown Steubenville in 1902. The congregation moved west to Lovers Lane in Steubenville's West End, as new homes were constructed in the subdivisions in the area. Lovers Lane is a street that was named in 1875 as a country lane in use with obvious purposes. (Photograph by Ron Smith.)

Temple Beth Israel. Jews settled in Steubenville in the mid-19th century. Several temples were established, but today only Temple Beth Israel remains. Constructed in 1965 on Lovers Lane, it serves the Jewish community in a beautiful, modern facility. (Photograph by Ron Smith.)

Five

BUSINESS AND COMMERCE

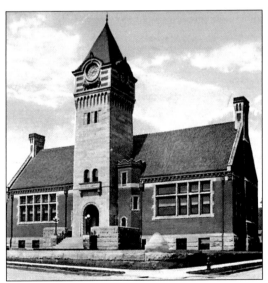 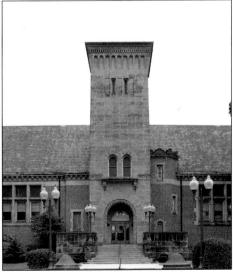

MAIN LIBRARY. The Main Library of the Public Library of Steubenville and Jefferson County was opened in 1902. Andrew Carnegie provided funds for the construction of the Richardsonian Romanesque building, designed by Alden & Harlow Architects of Pittsburgh. The postcard on the left shows the building as it appeared in 1924. In 1956, the top 35 feet of the tower were removed due to structural problems. The photograph on the right shows the building in 1996 with new exterior lighting. The building is listed on the National Register of Historic Places. (PLSJOC.)

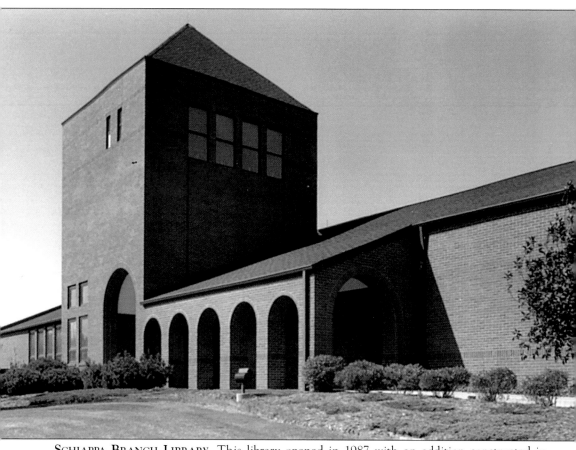

SCHIAPPA BRANCH LIBRARY. This library opened in 1987 with an addition constructed in 1992. The land was donated by John and Huberta Siciliano, in memory of her parents Albert and Mary A. Schiappa. It is located on Mall Drive in western Steubenville, near commercial developments. The building was designed by Michael T. Tabeling of Akron and is the largest library facility of the Public Library of Steubenville and Jefferson County. (PLSJOC.)

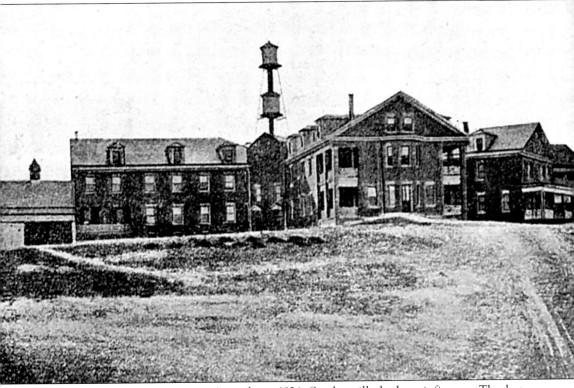

JEFFERSON COUNTY INFIRMARY. As early as 1824, Steubenville had an infirmary. The last known site for the Jefferson County Infirmary was on Sunset Boulevard and is now the site of Jefferson Community College. It is known that there once was a cemetery on these grounds, and there are at least two visible burials on the property. There are no known records for people buried there; however, the library does have some information available in the Local History Department. (PLSJOC.)

Steubenville, Ohio,

PUBLISHED BY JAMES WILSON,
PRINTER OF THE LAWS OF THE U. STATES.

In Market street, nearly opposite the Post Office.

TERMS.

The Western Herald will be published once in each week at two dollars per annum (exclusive of postage) payable half yearly in advance.

Subscribers served by the post rider or private post, $2 50 per annum.

Subscribers who fail to pay the amount of their subscriptions within every 6 months, shall at the expiration of the 6 months be charged 50 cents additional.

A failure to order a discontinuance of the paper is considered a new engagement.

*** All communications addressed to the Editor must be post paid.*

TERMS OF ADVERTISING.

First *three* insertions, *one dollar per square.* Every subsequent insertion 25 cents per do.

WESTERN HERALD. Steubenville's first newspaper was published in 1806 as a weekly. The name of the newspaper changed various times over the years. By the time this advertisement appeared on August 8, 1818, it was known as the *Western Herald and Steubenville Gazette*. Note the annual subscription of $2.50. Also note that the publisher was James Wilson, who was President Woodrow Wilson's grandfather. The newspaper is still in operation today under the name of the *Steubenville Herald Star*. (PLSJOC.)

WOOL WANTED.

—

THE SUBSCRIBERS WILL PURCHASE

WOOL,

At their Manufactory,

At the following prices, payable 12 months after delivery, viz

For full bred Merino, 80 cts. per lb. unwashed
7-8 do. 70 do. do.
 do. 60 do. do.
 do. 40 do. do.
 do. — do. do.
Common wool, 50 do. do.

If washed on the sheep's back, an addition will be made to those prices, equivalent to the advantage received in washing. The wool must be put up in good condition, without scraps or tag locks. Those who prefer taking our cloths in exchange for wool, to selling at 12 months credit, may be accommodated with cloths, as soon after the delivery, as their orders can be filled, which will not exceed four months after the delivery of

WOOL WANTED. This 1820 newspaper advertisement was placed by Steubenville co-founder Bezaleel Wells. He owned the first woolen mill in the United States. Because of this, Steubenville produced the first woolen cloth ever produced in the U.S. The first full-blooded Merino Sheep in the U.S. came to Steubenville from Spain for its wool. The mill opened in 1815 and operated until around 1829. Steubenville was the wool manufacturing center for this country in the 1820s. (PLSJOC.)

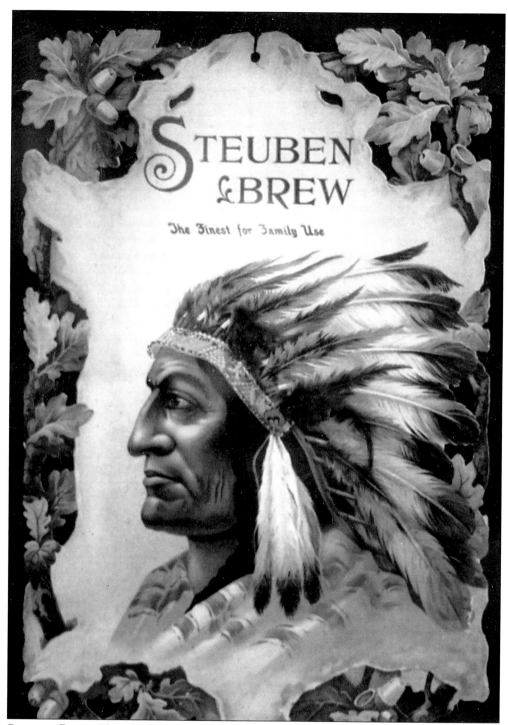

STEUBEN BREW. This photograph is of the original cardboard sign that was used for the beer called Steuben Brew. The original sign actually has real feathers on it. The beer was made at City Brewery, which began in 1860 and supplied Steubenville with its lager beer for almost 60 years. German immigrant John Butte was the first brew master. (PLSJOC.)

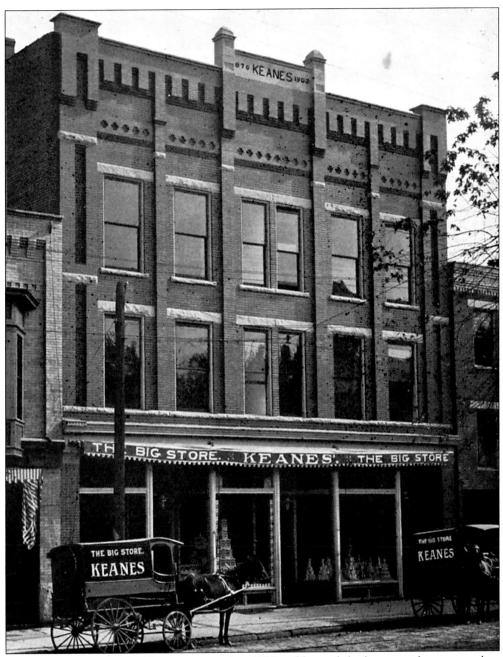

KEANE'S STORE. This building was erected in 1876 and housed the largest and most complete retail grocery store in the Ohio Valley. It was located in the 100 block of South 3rd Street. The top of the building was added in 1902, as seen by the date on the frieze. Michael Keane was the proprietor, and from 1901–1913, he was a member of the Board of the Carnegie Library, now the Public Library of Steubenville and Jefferson County. (PLSJOC.)

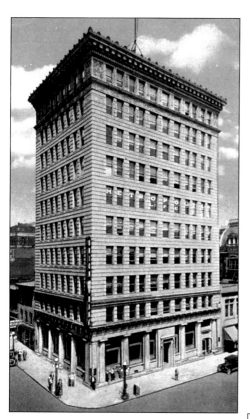

UNION SAVINGS BANK & TRUST CO.
This 1929 postcard depicts the city's first skyscraper, which was built in 1914. The 10-story building is known as the Sinclair Building and originally housed the Union Savings Bank, which had its beginnings in 1854. The bank's name has changed several times; it is today known as Sky Bank, which still uses this building for part of its banking business. (PLSJOC.)

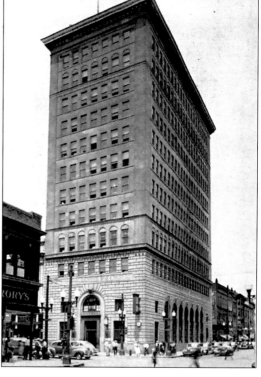

NATIONAL EXCHANGE BANK AND TRUST CO. This bank had its beginnings in 1816 as the Farmers and Mechanics Bank of Steubenville. The name was changed to National Exchange Bank and Trust Co. in 1874. It was in various locations until this building was completed in 1922. Today, the building houses Bank One. (PLSJOC.)

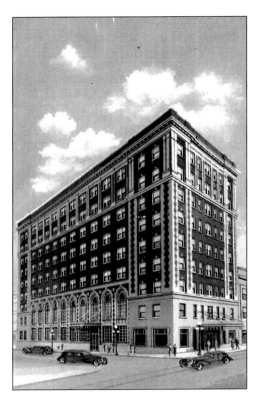

FORT STEUBEN HOTEL. This postcard shows the hotel as it opened in 1920. It was located at the corner of 4th and Washington Streets and in its heyday was the place to go for dinner and entertainment. Beginning in 1986, it operated as an apartment building for senior citizens, called the Fort Steuben Apartments. (PLSJOC.)

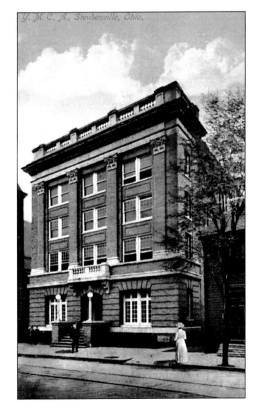

YMCA. The Young Men's Christian Association building was erected in 1909 for $80,000. The organization's history actually dates back to 1867. This building is on North 4th Street and has been renovated into senior apartments. (PLSJOC.)

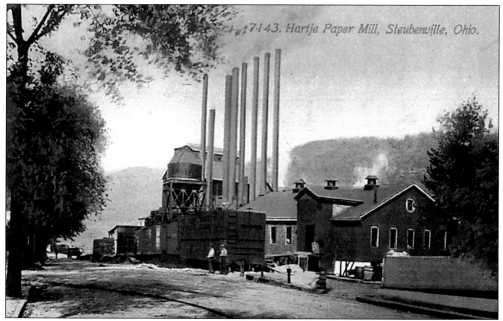

HARTJE PAPER MILL. This postcard shows a view of the paper mill. It employed 200 people and was one of the largest paper mills in the U.S., producing newsprint, wrapping paper, straw, and pulp board. In 1897, it produced over 80 tons of paper products per day. A. Hartje of Pittsburgh owned the mill; later it was operated by his sons under the name Hartje Brothers. (PLSJOC.)

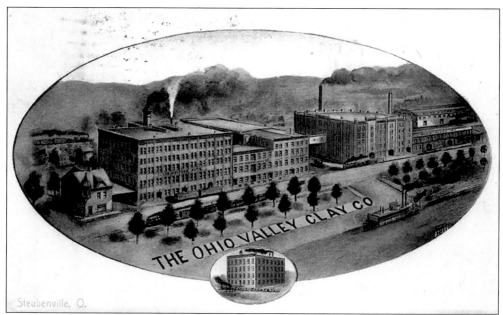

OHIO VALLEY CLAY CO. This business was organized by the Gill Brothers in 1882 and was located at Washington and Water Streets. They manufactured glass house pots, tanks, furnace bricks, stoppers, and rings. These products were shipped to all parts of the United States and exported to Canada. The buildings existed into the 1980s and were demolished to make way for the Jefferson County Justice Center. (PLSJOC.)

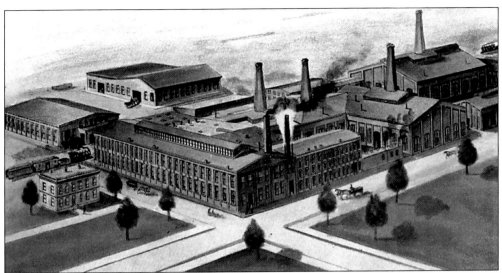

ACME GLASS WORKS. This factory began in 1874 and was the largest lamp chimney factory under one roof in the U.S. They exclusively manufactured lamp chimneys and silvered glass reflectors. Around 1897, the capacity of the glass works was up to 500,000 lamp chimneys per week with about 700 employees. These workers were known as the best glass workers in America. (PLSJOC.)

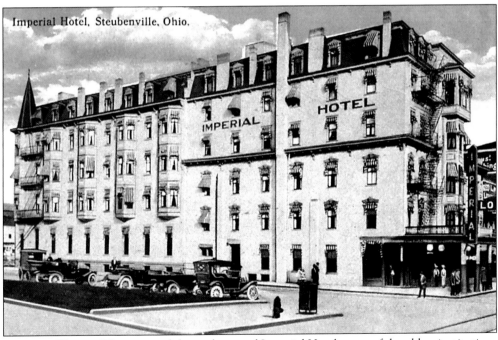

IMPERIAL HOTEL. This postcard shows the grand Imperial Hotel—one of the oldest institutions in Steubenville. It opened around 1870 at the corner of 6th and Market Streets. The hotel was across the street from the Pennsylvania Railroad Station and had a streetcar ticket office. It was a working class hotel and had a bar called the Revel Room, a barbershop, a donut shop, and a drug store. Many rooms had private baths—quite a novelty at that time. The last of the building was demolished in 1998. (PLSJOC.)

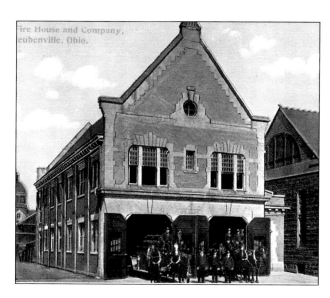

RELIANCE FIRE HOUSE AND COMPANY. This postcard shows Steubenville's second paid fire department's house, which was organized in 1886. At this point, it had been moved to a new building on North Street, constructed in 1909. It now serves today's Steubenville Fire Department. In 1870, the city purchased its first steam fire engine, which was housed in the Phoenix engine house. A year later, another steam engine was purchased and housed at the Reliance Station. In earlier days, the city relied on a bucket brigade for fighting fires. (PLSJOC.)

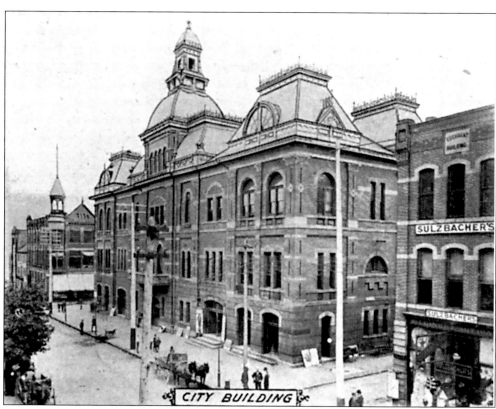

CITY BUILDING. This City Building was constructed in 1883 at the corner of 3rd and Market Streets, across the street from the Jefferson County Courthouse. It was demolished in the 1920s, and the new City Annex was constructed on the same site. (PLSJOC.)

THE BUSINESS DISTRICT AT 5TH AND MARKET STREETS. The heart of the business district in 1947 featured The Hub Department Store, S.S. Kresge, and F&W Woolworth Co., all at the corner of 5th and Market Streets. The parking spaces are full, as Steubenville was the shopping mecca of Eastern Ohio. (PLSJOC.)

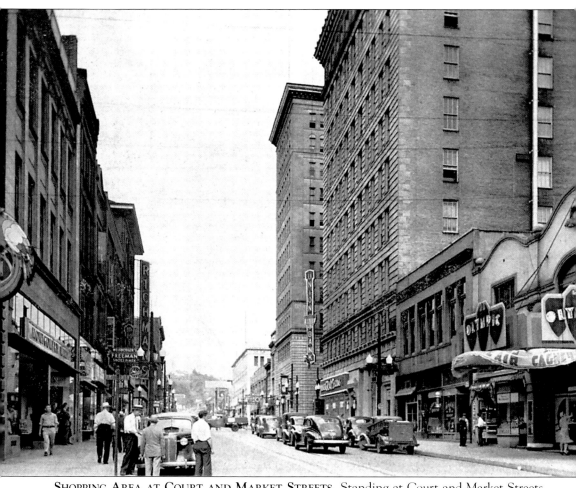

SHOPPING AREA AT COURT AND MARKET STREETS. Standing at Court and Market Streets, the downtown shopping area contains (left to right) Montgomery Ward, Weisberger's Freeman Shoes for Men, Richman's, Union Bank, Gray Drugs, and the Olympic Theater. (PLSJOC.)

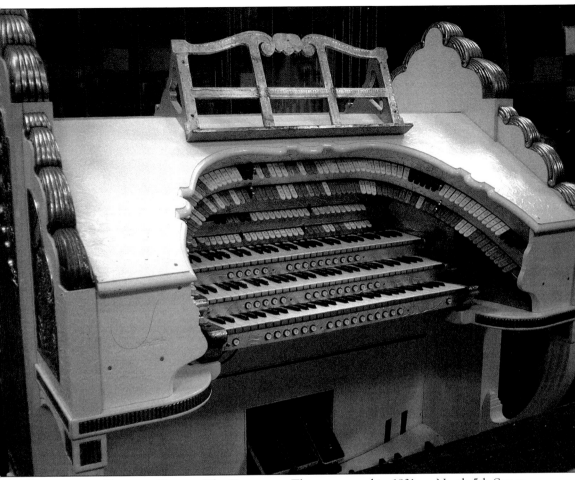

PARAMOUNT THEATER ORGAN. The Paramount Theater opened in 1931 on North 5th Street behind The Hub Department Store. This is the actual organ that was used in the early days of the theater. The theater was demolished in the 1970s. (PLSJOC.)

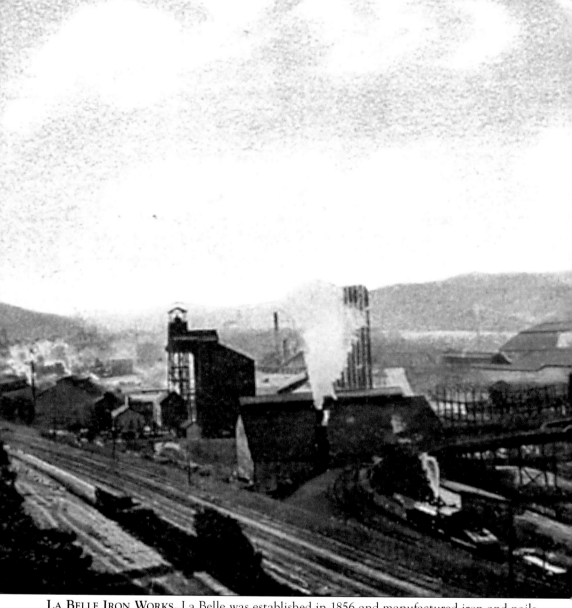

LA BELLE IRON WORKS. La Belle was established in 1856 and manufactured iron and nails. By 1859, the stockholders purchased the Jefferson Iron Works. In 1919, the income was

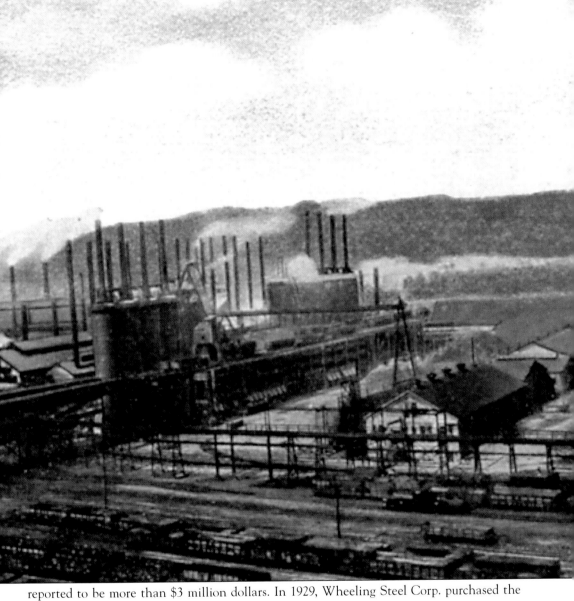

reported to be more than $3 million dollars. In 1929, Wheeling Steel Corp. purchased the works. (PLSJOC.)

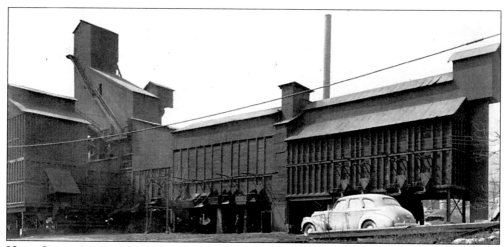

HIGH SHAFT MINE. This image is of the "High Shaft" of the Steubenville Coal and Mining Company. It provided fuel for railroads, industries, and city residents beginning in the Civil War days. The first vein of coal found in Steubenville was in 1829 and was 225 feet deep. The High Shaft was located at 8th and Market Streets and was used as early as 1858. Its operations extended three miles underground from the opening. The mine officially closed in 1964 and is the site of today's Market Square Apartments and the Martin Luther King Jr. Recreation Center. (PLSJOC.)

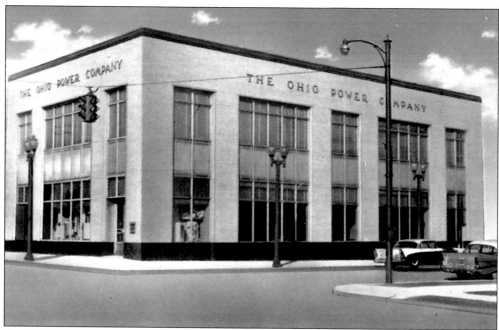

OHIO POWER COMPANY. The downtown office building for Ohio Power Company was constructed in 1937 at 5th and Washington Streets. In 1989, it was acquired by American Electric Power (AEP) and moved to its new $12 million facility on John Scott Highway. (PLSJOC.)

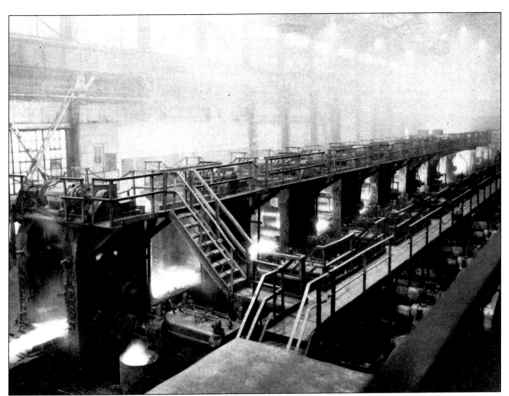

WHEELING STEEL CORP., STEUBENVILLE WORKS. This 1947 image shows the ribbons of steel rolling through the Continuous Hot Strip Mill. (PLSJOC.)

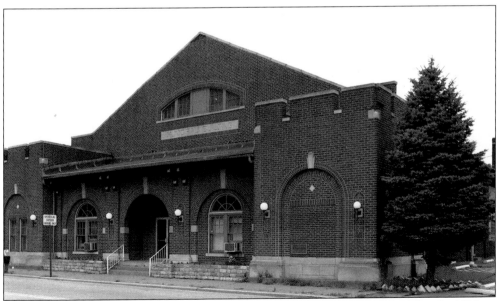

STEUBENVILLE MUNICIPAL BUILDING. The Municipal Building was constructed in the 1920s as a Market House and today houses the Police Department, City Council, and Municipal Court. The building has been recently renovated. (PLSJOC.)

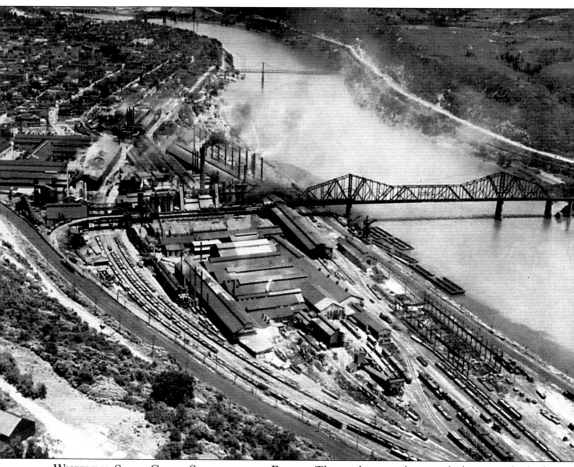

WHEELING STEEL CORP., STEUBENVILLE PLANT. This is the sprawling steel plant as it looked in 1947, with the bridge connecting the plant to works in Follansbee, West Virginia. Today, this is the North Plant of Wheeling-Pittsburgh Steel Corporation. (PLSJOC.)

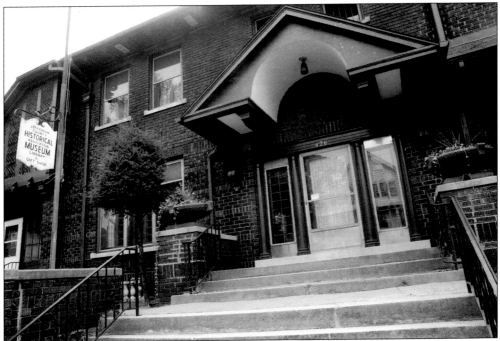

JEFFERSON COUNTY HISTORICAL ASSOCIATION. This historical society began in 1973 to preserve, protect, and promote the history of Jefferson County. The association offices have been in the Sharpe Mansion on Franklin Avenue since 1976. This photograph shows the house, now a museum with exhibits and a genealogical library. Displayed at the museum is the "Stanton Desk," believed to have belonged to Edwin M. Stanton; it was housed for many years at the public library. (PLSJOC.)

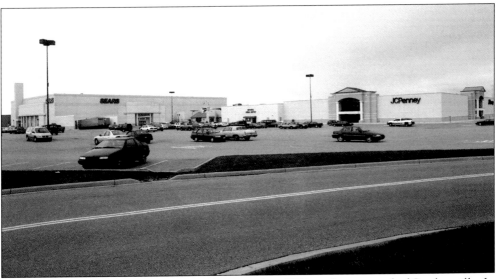

FORT STEUBEN MALL. The mall was constructed in 1974 in the west end of Steubenville. In 2000, a $30 million dollar expansion brought much change to the mall, including new stores and renovations to Kauffmans, Sears, and Penneys, the anchor stores, as well as the addition of a Super Wal-Mart Store. (Photograph by Ron Smith.)

TRINITY MEDICAL CENTER EAST. Known as Ohio Valley Hospital when it opened in 1912, the hospital expanded many times while occupying the site on Pleasant Heights, where Bezaleel Wells' great granddaughters continued to reside. In 1997, the hospitals merged into Trinity Health Systems. (Photograph by Ron Smith.)

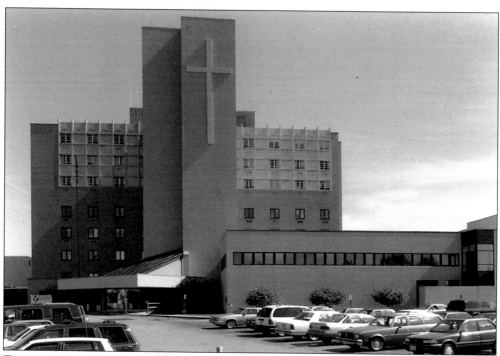

TRINITY MEDICAL CENTER WEST. Opened in 1960 as St. John Medical Center, the hospital merged with Gill Hospital in 1968, which had been operated by the St. Francis of Sylvania Order since 1901. It joined Trinity Health Systems in 1997. (PLSJOC.)

Six

STANTON PARK

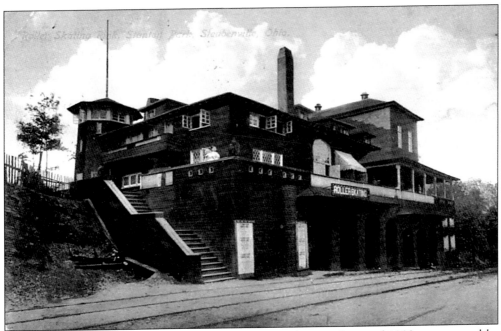

STANTON PARK ROLLER SKATING RINK. Stanton Park opened around 1900, constructed by the local traction company as a destination to use their streetcar service. The Roller Rink was east of the trolley tracks and had skating contests around 1915. Later called the Half Moon Roller Rink, the building lasted past the closing of the park in the 1940s. (PLSJOC.)

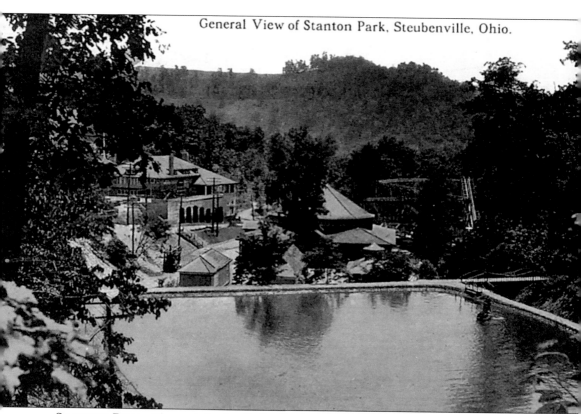

STANTON PARK. The park had a Roller Rink, a Midway, and much more to attract area residents. The park was named for Steubenville native, Edwin M. Stanton, Lincoln's Secretary of War. It was located west of the Steubenville Water Works Pumping Station, the site of the State Route 7 and U.S. 22 interchange today. The 85-acre park had a roller coaster that cost 5¢ a ride, or 3 rides for 10¢. (PLSJOC.)

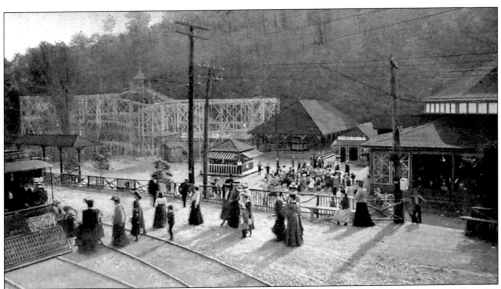

STANTON PARK. People arrived at Stanton Park via the streetcar lines, owned by the Steubenville and East Liverpool Traction and Light Company. The park provided a reason to use the trolley system, and park-goers arrived from both cities. The Merry-Go-Round building could accommodate 1,000 people and the mighty Wurlitzer organ played music all day, with dance contests in the evening. As people acquired automobiles, these trolley parks became less popular as people could drive to a greater variety of destinations. (PLSJOC.)

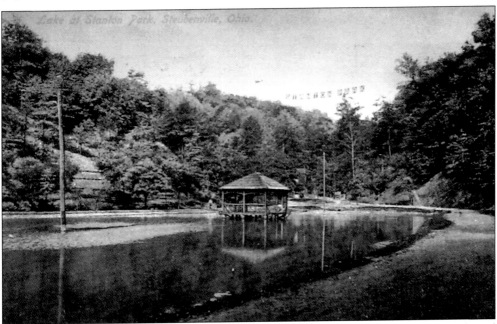

LAKE AT STANTON PARK. This postcard shows the lake at Stanton Park, with the Bandstand at one end. Most of the park's attractions were in decline by the 1930s, and as the trolley line closed, the park closed by the 1940s. The Roller Rink stayed open into the 1950s and was referred to as Half Moon Casino, popular with gamblers and dancers. The construction and widening of area highways wiped out the last traces of the park. (PLSJOC.)

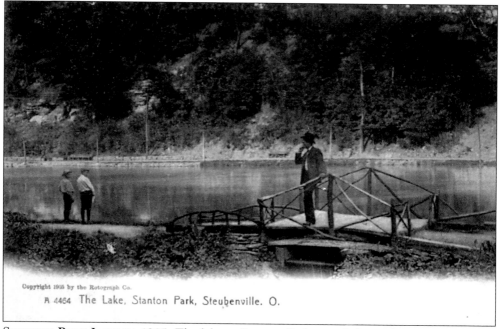

A 4464 The Lake, Stanton Park, Steubenville. O.

STANTON PARK LAKE IN 1905. The lake at Stanton Park provided a cool respite from a hot, humid summer day in the Ohio Valley. A foot bridge with railings fashioned from trees that were removed for construction of the park gave it a rustic feel. This 1905 photograph shows the spillway that allowed water to leave the lake. (PLSJOC.)

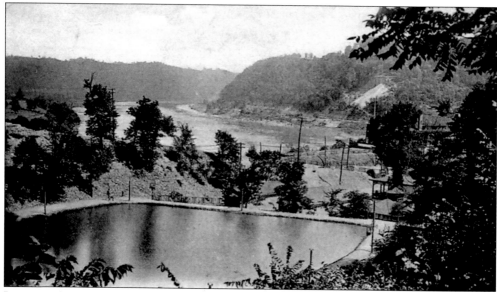

LAKE AT STANTON PARK IN 1908. This 1908 view of Stanton Park's lake shows the Half Moon bend in the Ohio River in the background and the trolley and railroad line hugging the riverbank on its way to Steubenville around the next hill. The artificial lake was placed in the end of the valley. Today, the traffic lights on State Route 7 and State Route 213 would be in the middle of the lake site. (PLSJOC.)

Seven

EDUCATION
1829–2004

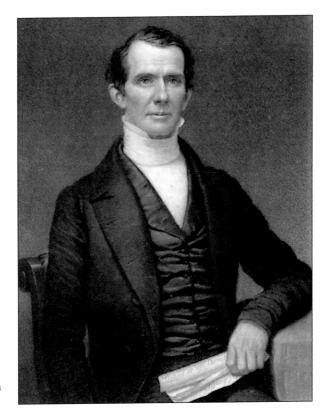

REVEREND CHARLES C. BEATTY.
Reverend Beatty established the
Steubenville Female Seminary
in 1829. This all-girls school was
sometimes called the "Ladies
Seminary." He was the son of
Colonel Erkuries Beatty, who
was the regimental paymaster
for the 1st American Regiment,
which brought him to Fort
Steuben. Reverend Beatty came
to the city as the minister of the
First Presbyterian Church and
organized the Second Presbyterian
Church here. (PLSJOC.)

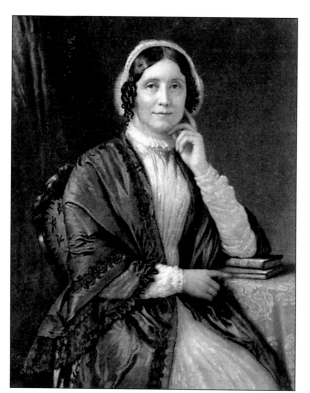

HETTY BEATTY. Mrs. Beatty was instrumental in the daily operations of the Steubenville Female Seminary. She was affectionately known as "Mother Beatty" by her students. She taught a Bible Class at her husband's church, with Edwin M. Stanton a class member as a young boy. It was her desire to have such a school where she could be a teacher. (PLSJOC.)

REVEREND DR. A.M. REID. Dr. Reid was the second headmaster of the Steubenville Female Seminary, taking over from the Beattys in 1856. Dr. Reid managed the all-girls school until its demise in 1898. (PLSJOC.)

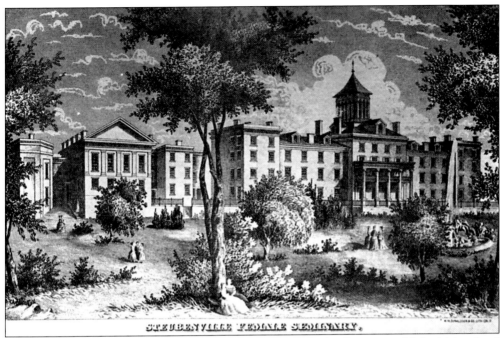

STEUBENVILLE FEMALE SEMINARY. Reverend Beatty and Mrs. Beatty established his school for girls in 1829. The buildings faced the Ohio River, and it was located on South High Street between Adams and South Streets. When it closed in 1898, nearly 5,000 women had graduated from the school since its founding. (PLSJOC.)

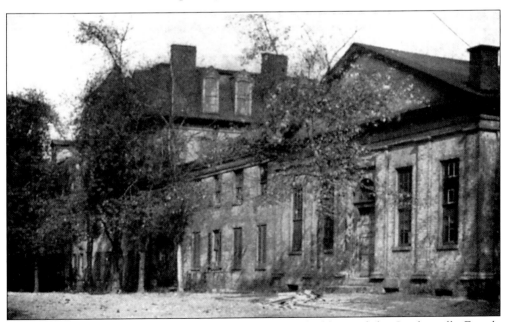

SEMINARY BUILDINGS. Following its 1898 closing, the buildings of the Steubenville Female Seminary served other purposes. By the 1940s, the buildings that survived were apartments. In 1953, the remaining buildings were demolished for construction of the "High Street Thoroughfare," today known as State Route 7. (PLSJOC.)

CARNEGIE'S START -- The following is going the rounds of the press: Thirty-seven years ago there was a big flood in the Ohio River. The smoke stacks of a steamboat caught the telegraph wires which crossed the river at Steubenville, O., and swept them away. The telegraph company sent a bright young operator, not yet sixteen years old, to that point to take care of the messages there until the lines could be repaired. The youth was ambitious, and as that was his first opportunity to distinguish himself, he did his work well. He would receive and write out the messages and then every few hours would hire a man to take them in a boat on the high water to Wheeling. The young operator was commended for his work and promoted. His name? Andrew Carnegie, the great iron and steel manufacturer. His exploit of a generation ago was recalled by his visiting Steubenville on last Wednesday to meet the Pan-American visitors and escort them into Pittsburgh.

"CARNEGIE'S START." This December 3, 1889, article in the *Steubenville Herald* explains Andrew Carnegie's connection to Steubenville, working as a young boy on the telegraph in the city around 1850. This is also his only documented visit to Steubenville as an adult. (PLSJOC.)

CARNEGIE'S LETTER

The generous offer of Andrew Carnegie to build a public library for Steubenville, which was made in a letter to Dr. A. M. Reid, an exclusive account of which was printed in the HERALD STAR of yesterday, created much favorable comment in the city last evening, the universal opinion being that an effort should be made to secure the building under the conditions stated by Mr. Carnegie. The matter will probably be brought before the City Council in an official way at its next meeting.

Following is a copy of Mr. Carnegie's letter to Dr. Reid:

SKIBO CASTLE, ARDGAY, N. B., June 30th, 1899.

Telegrams, Dornoch Station, Bonar Bridge.

A. M. Reid, Esq., Steubenville, O:

DEAR SIR:—If the town of Steubenville will furnish the site and agree to maintain the Free Library at a cost of not less than $4,000 per year, I will provide funds as needed for the building up to $50,000.

Very Truly Yours,
ANDREW CARNEGIE.

CARNEGIE LETTER. Dr. A.M. Reid wrote to Andrew Carnegie asking for his funding of a library for the city. The response came from Skibo Castle in Scotland, Carnegie's summer residence, and appeared in the *Steubenville Herald Star* on July 18, 1899. Carnegie would give $50,000 if the city maintained the library and provided a site. In the end, Carnegie provided another $12,000 to complete the library building. (PLSJOC.)

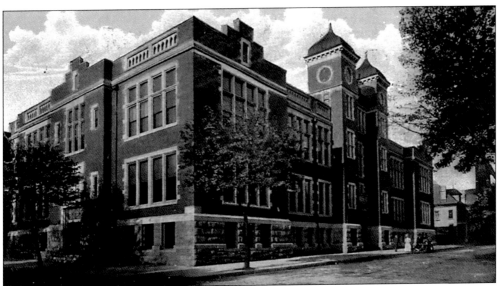

WELLS HIGH SCHOOL. This 1908 postcard shows Wells High School, which was constructed in 1906 at 4th and North Streets for $100,000. It was destroyed by fire in 1942 as over 100 firemen tried to extinguish the fire. The school was named for Bezaleel Wells, the co-founder of Steubenville. Wells is credited with "practically inaugurating the first public school in the State of Ohio." The current high school building was already in use when Wells School was destroyed by fire. (PLSJOC.)

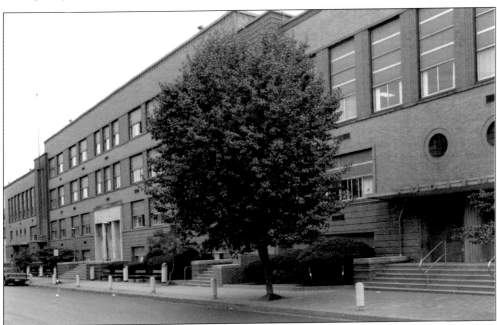

STEUBENVILLE HIGH SCHOOL. The building was opened in 1940 and billed as a million dollar high school. The enrollment at that time was 1,285. It was erected on the site of old Stanton School. This school, also known by its nickname of "Big Red," occupies the entire block. In 1994, major renovations of over $10 million added a commons area, gymnasium, and natatorium. (Photograph by Ron Smith.)

GARFIELD ELEMENTARY SCHOOL. Replacing a school with the same name, this building was completed in 1960. The earlier school was located at 806 North 5th Street; this building is at 936 North 5th Street. (Photograph by Ron Smith.)

McKINLEY ELEMENTARY SCHOOL. Replacing a school with the same name, this building was completed in 1963. The former building was demolished in 1964. (Photograph by Ron Smith.)

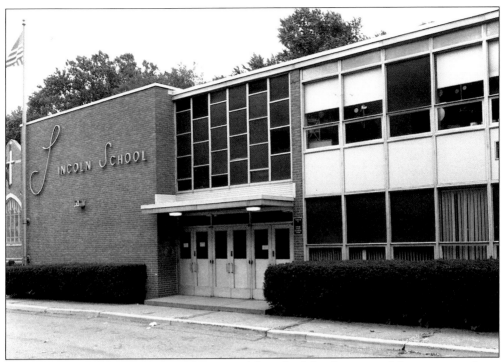

LINCOLN ELEMENTARY SCHOOL. The original Lincoln School contained four rooms and was constructed in 1891. This building was opened in 1960. (Photograph by Ron Smith.)

BUENA VISTA ELEMENTARY SCHOOL. This building opened in 1948 as a five-room school. It was renovated in 1961. It replaced an earlier building with the same name. (Photograph by Ron Smith.)

WELLS ELEMENTARY SCHOOL. This building was constructed in 1916 as an Annex to Wells High School, connected by an archway over the alley. Because of the construction, the building was spared from the 1942 fire that destroyed the high school. It was renovated in 1961 and closed in 1976. It reopened again in 1985 as a "School of Choice." (Photograph by Ron Smith.)

ROOSEVELT ELEMENTARY SCHOOL. This Belleview Boulevard school was opened in 1969 to replace a 1929 building on Maryland Avenue with the same name. (Photograph by Ron Smith.)

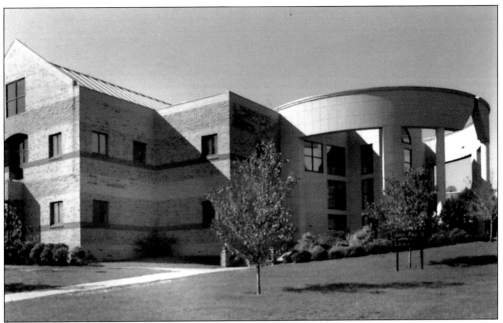

JOHN PAUL II LIBRARY, FRANCISCAN UNIVERSITY. The College of Steubenville was established in 1946 in a building downtown on Washington Street. Today located on the hilltop on University Boulevard, Franciscan University of Steubenville educates students representing all 50 states and many countries. This is the new John Paul II Library on campus. (Photograph by Ron Smith.)

JEFFERSON COMMUNITY COLLEGE. Established in 1966 and named Jefferson Technical Institute, the school had an initial enrollment of 320. By 1977, it was known as Jefferson Technical College with additional classrooms and tennis and basketball courts. In 1995, it became Jefferson Community College with additional labs, classrooms, and offices added around that time. In 2003, JCC acquired the vacated AEP building across the street from the college for additional space. (Photograph by Ron Smith.)

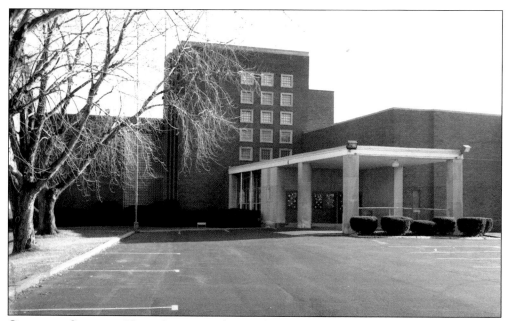

CATHOLIC CENTRAL HIGH SCHOOL. This Catholic high school opened its doors in 1950, replacing Holy Name High School, which dated back to 1882 and was located on South 5th Street. Many improvements have been made over the years. The school's athletic teams have been called "The Crusaders" since 1946. (Photograph by Ron Smith.)

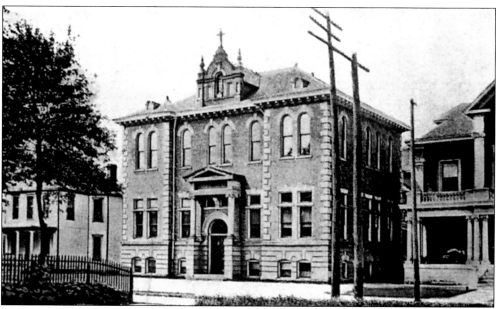

HOLY NAME PAROCHIAL SCHOOL. This building was constructed around 1889, with 250 students in attendance by 1897. The cover photograph shows Reverend Hartley, priest of Holy Name Church, escorting many school children in the Centennial Parade. An additional building was constructed across the street to expand the high school and was known as Holy Name High School. This building has been demolished, but the façade was retained with a park behind it. (PLSJOC.)

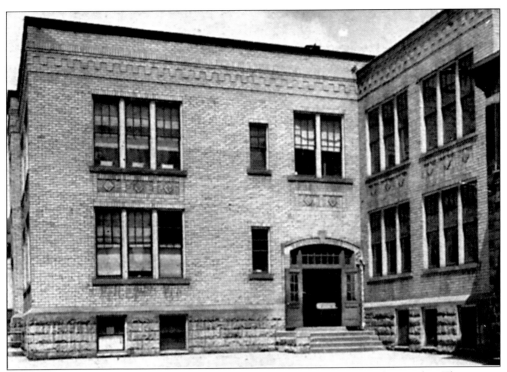

ALL SAINTS SCHOOL. Parochial schools began in Steubenville in 1853 when Father Thienpoint opened a school at St. Pius Church (now St. Peters). This school building was opened in 1912 as St. Peters School. Today, it is All Saints School. (PLSJOC.)

HARDING MIDDLE SCHOOL. Opened in 1926, Harding School cost $400,000 to build and equip and was the only local school with a cafeteria. The complex was renovated in 1987. The building was demolished in 2002 with the construction of the new Harding School on the school's adjacent lot. (Photograph by Ron Smith.)

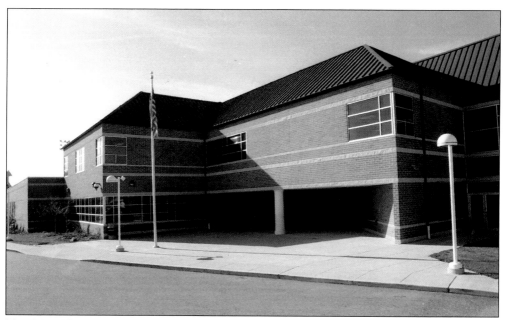

THE NEW HARDING MIDDLE SCHOOL. The Ohio School Facilities Commission and voters of the Steubenville City School District constructed the new Harding Middle School in 2002 at a cost of more than $11 million dollars. (Photograph by Ron Smith.)

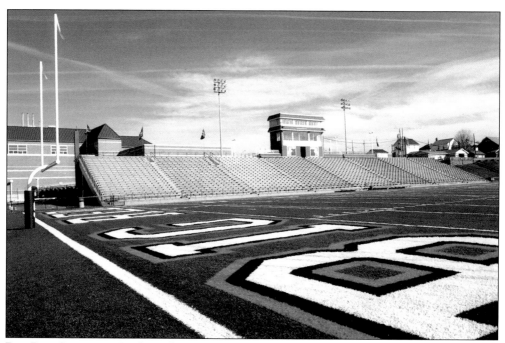

BIG RED STADIUM. Steubenville High School's football stadium is located behind Harding Middle School and is commonly known as "Big Red Stadium." It was constructed in 1930, with an electric scoreboard added in 1946. Artificial turf was added in 2004 at a cost of $400,000. Catholic Central High School also uses the stadium. (Photograph by Ron Smith.)

Eight

FORT STEUBEN, COURT HOUSE, AND LAND OFFICE

THE PLAN OF FORT STEUBEN. This drawing of Fort Steuben was done in early 1787 by Lieutenant Ebenezer Frothingham and was placed in Major Erkuries Beatty's paymaster diary. The blockhouses show the corners of the fort with officer's quarters, commissary, quartermaster, magazine, and artificer's shop forming the buildings, surrounded by pickets. The main gate faces the Ohio River. Fort Steuben was constructed to protect the surveyors working in the Seven Ranges. It was abandoned in May 1787 when the surveying work was completed. (PLSJOC.)

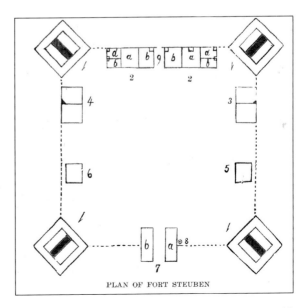

PLAN OF FORT STEUBEN

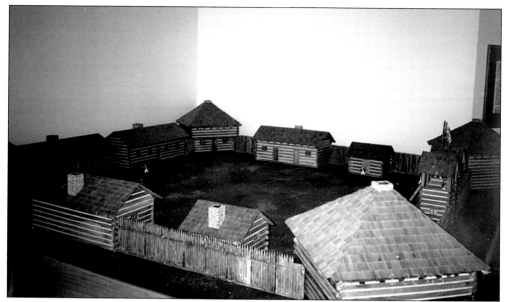

FORT STEUBEN REPLICA. This replica of Fort Steuben was built by John Flenniken, a retired teacher and area resident. It is on display at the Visitor's Center Exhibition Hall at the Fort Steuben site on 3rd Street. (Photograph by Ron Smith.)

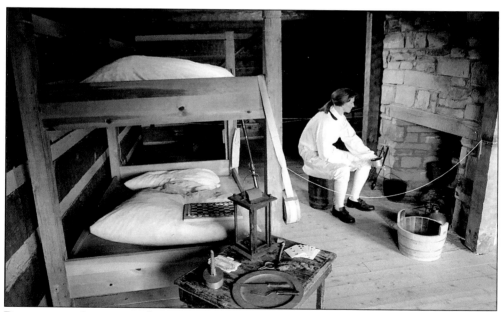

BLOCKHOUSE INTERIOR. The square blockhouses are set at an angle at each corner of Fort Steuben. They are 25feet square, designed to accomodate 28 enlisted men on the bottom floor. The top floor had gun ports to protect the fort. Since soldiers were assigned sentry duty, patrolling, and reconnoitering, not all men would be in their quarters at the same time. A double-sided fireplace was in the center of each blockhouse for heat and for cooking, with beds filling the remaining space. (Photograph by Ron Smith.)

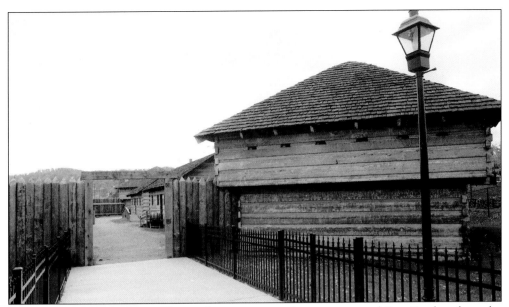

FORT STEUBEN ENTRANCE. This is the entrance to the reconstructed Fort Steuben from the Visitor's Center. In 1986, on the 200th anniversary of the construction of the fort, ground was broken for the reconstruction of the fort. Work was completed in 2000 on the reconstruction. It has been reconstructed as an exact reproduction of the original fort, on the site designated in 1897 as the site of Fort Steuben. (Photograph by Ron Smith.)

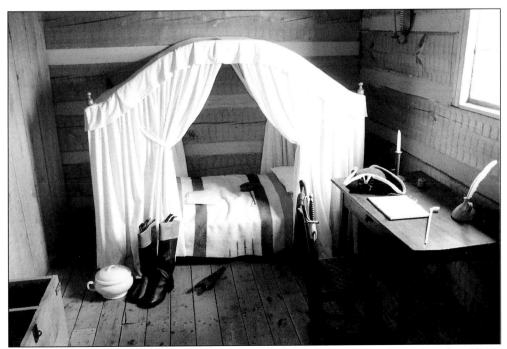

FORT STEUBEN INTERIOR. Captain John Francis Hamtramck's quarters, located in the officer's quarters, has been reconstructed to show the accommodations for the commander of Fort Steuben. He has a writing desk, canopy bed, and chamber pot in his room. The enlisted soldiers at the fort lived in the blockhouses—28 men in a space of 300 square feet. (Photograph by Ron Smith.)

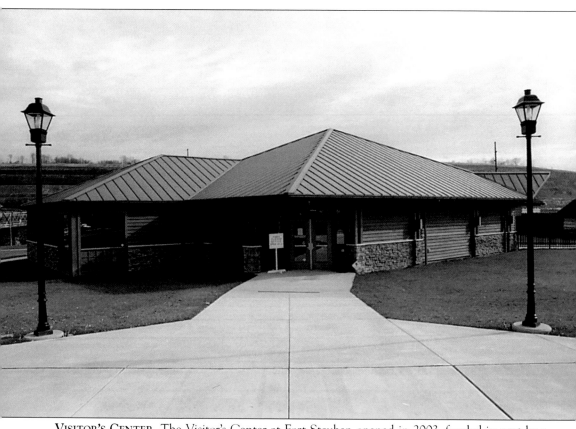

VISITOR'S CENTER. The Visitor's Center at Fort Steuben opened in 2003, funded in part by a Scenic Byways grant from ODOT. It provides offices for Fort Steuben, an exhibit hall, a museum shop, a conference room, and offices for the Steubenville Visitor's and Convention Bureau. In the park surrounding the center, there is Veteran's Fountain that is surrounded by bricks purchased to honor area citizens. (Photograph by Ron Smith.)

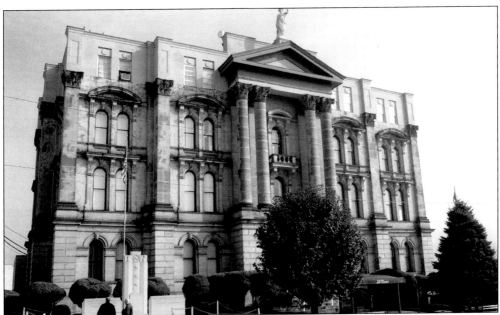

JEFFERSON COUNTY COURT HOUSE. This is the third court house building that has occupied this site at 3rd and Market Streets in Steubenville. This Romanesque-style building with a Greek portico was completed in 1874 at a cost of $300,000. The original Mansard roof was lost in 1950 when it collapsed under the weight of Steubenville's largest snowfall. Reconstruction squared-off the fourth floor to the design seen today. (Photograph by Ron Smith.)

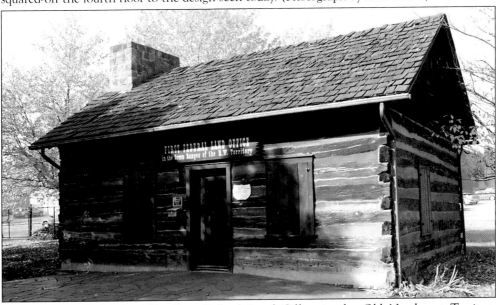

FEDERAL LAND OFFICE. The First Federal Land Office in the Old Northwest Territory was established in Steubenville on May 10, 1800. The Land Office was closed in 1840 and rediscovered in the 20th century inside another commercial structure. It was moved three times, with its final move back to 3rd Street near its original location, where it was restored. The Land Office and Fort Steuben form a historic block where visitors can relive history. (Photograph by Ron Smith.)

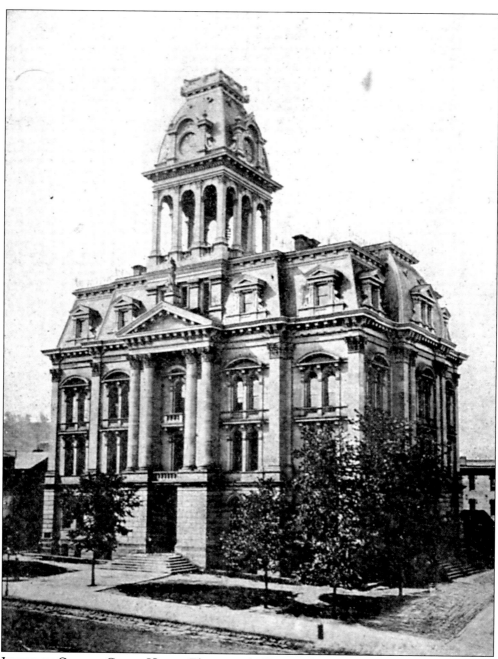

JEFFERSON COUNTY COURT HOUSE. The original 1874 court house had a Mansard roof and tower to grace its architectural lines. By 1920, structural problems plagued the tower and repairs were made. The Thanksgiving snowstorm of 1950 caused the roof to collapse onto much of the fourth floor, and options were considered for reconstruction or replacement of the building. By 1953, the fourth floor had been reconstructed as a full fourth floor, increasing office space. (PLSJOC.)

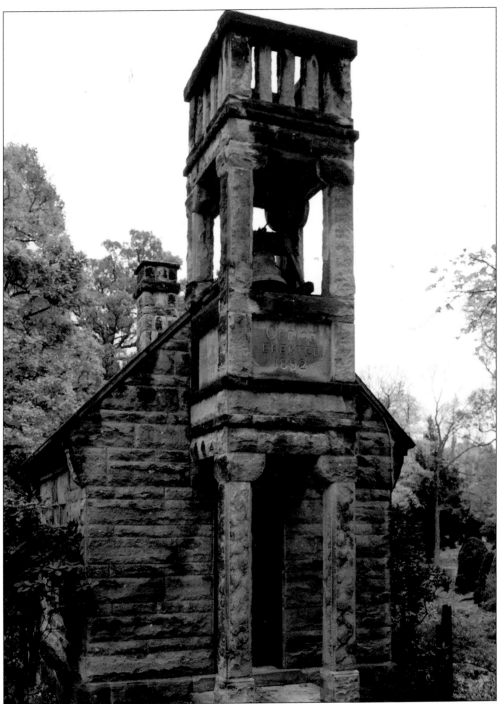

JEFFERSON COUNTY'S FIRST COURT HOUSE BELL. The bell in the steeple of the Old Union Cemetery Office, erected in 1892, is the first court house bell used in the county. It was made in 1813, placed in the second court house, and was used to inform people when someone was approaching the settlement. It also rang during the Civil War to announce that John Hunt Morgan was entering the county on his famous raid. (Photograph by Ron Smith.)

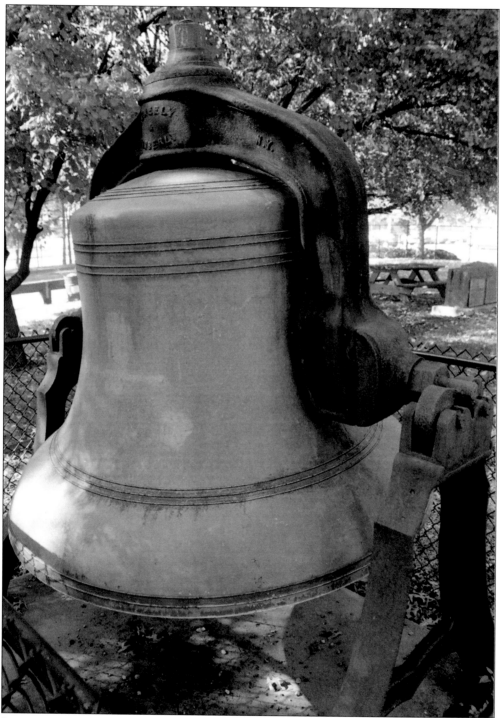

Jefferson County Court House Bell. This bell was originally located in the tower of the 1874 court house building. It was removed in 1923 for safety reasons. It is now located on the grounds of the Land Office. The bell originally rang every 30 minutes; now it rings to celebrate July 4th. The bell weighs 5,700 pounds and cost $2,081. (Photograph by Ron Smith.)

Nine

MURALS, MARKERS, AND STATUES

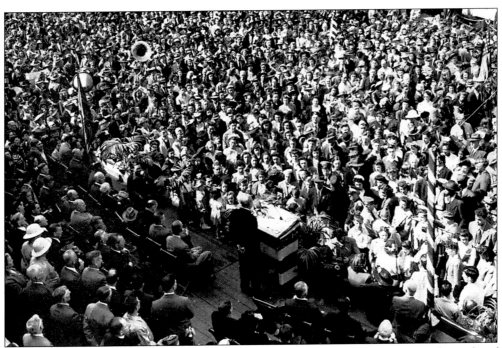

DEDICATION OF THE JEFFERSON COUNTY HONOR ROLL. On April 30, 1944, in the midst of World War II, this immense crowd gathered around the Jefferson County Court House for the dedication of the World War II Honor Roll. (PLSJOC.)

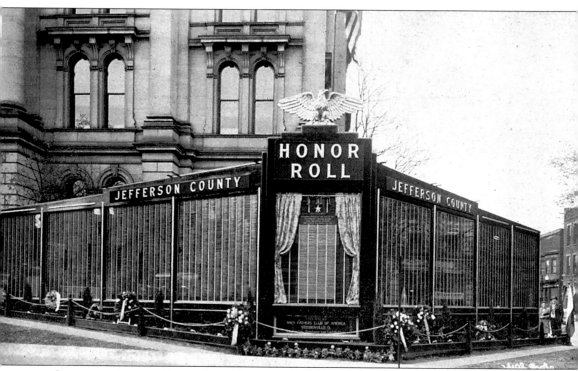

JEFFERSON COUNTY HONOR ROLL BOARD. The World War II Honor Roll Board contained the names of more than 12,000 men and women from Jefferson County who served in the Armed Forces during that war. The board was placed on the Courthouse lawn facing Market Street. Like many other such Honor Rolls around the nation, it was removed due to deterioration after the war ended. (PLSJOC.)

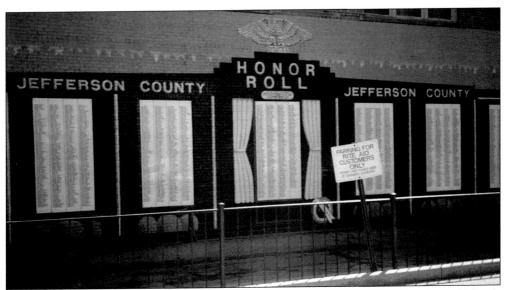

JEFFERSON COUNTY HONOR ROLL BOARD MURAL. As part of Steubenville's City of Murals Project, this mural was painted to recreate the original Honor Roll from 1944. Many of the names from the original board have been painted on this mural, located on the side of a building on Market Street between 4th and 5th Streets. (Mural by artists David and Susan Frye, photograph by Ron Smith.)

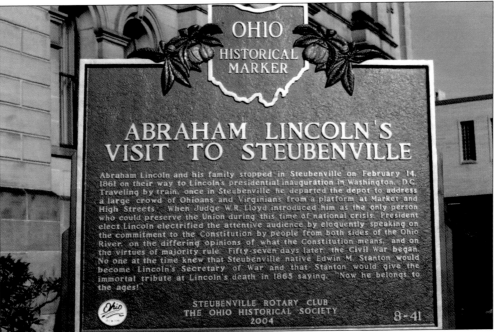

ABRAHAM LINCOLN'S STEUBENVILLE VISIT. On February 14, 1861, President-Elect Abraham Lincoln and family stopped in Steubenville on their way to his inauguration in Washington, D.C. This marker is in the Court House yard; the original speech was delivered near the Train Station at the foot of Market Street. A re-enactment was held in 2004 dedicating the Ohio Historical Marker. (Photograph by Ron Smith.)

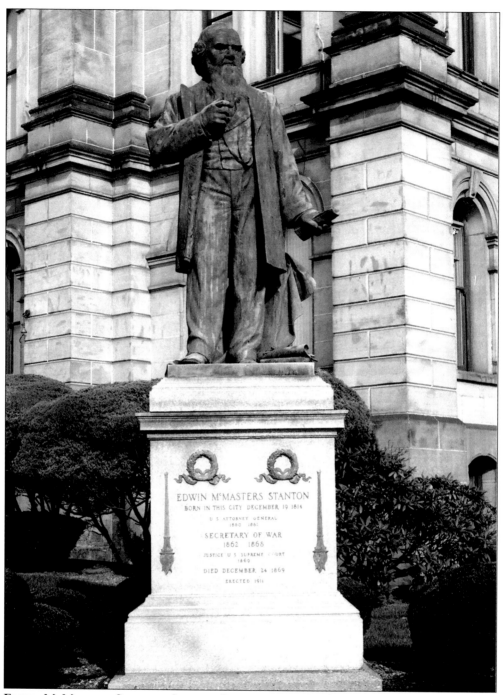

EDWIN MCMASTERS STANTON STATUE. Born in 1814 in Steubenville, Edwin M. Stanton was Lincoln's Secretary of War. He died in 1869 just days after being appointed to the U.S. Supreme Court by President Grant. The upside down torches on the statue symbolize death, the burning flame signifies eternal life, as an upside down torch would normally extinguish itself. The wreaths are a symbol of eternal life because they are circular and made of evergreens. The statue is in the Court House yard at 3rd and Market Streets. (Photograph by Ron Smith.)

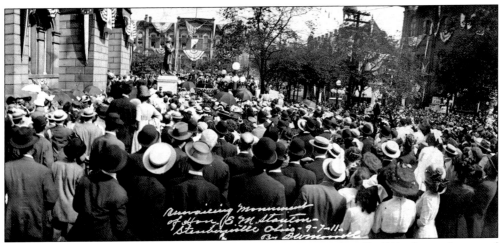

STANTON STATUE DEDICATION. This photograph on September 7, 1911, shows the crowd gathered for the unveiling and dedication of the Edwin M. Stanton statue, located on the pedestal outside the Courthouse. Originally, the statue was located at the Market Street steps of the Court House, and in 1963, it was moved to the corner of 3rd and Market Streets on the lawn. (PLSJOC.)

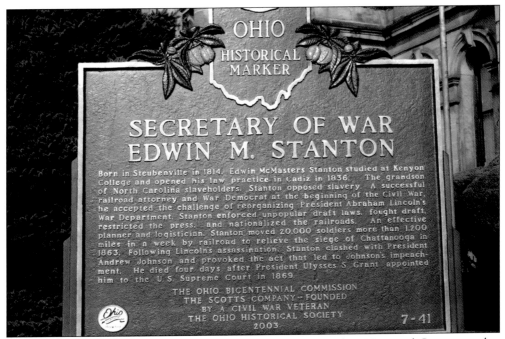

EDWIN M. STANTON HISTORICAL MARKER. In 2003, the Ohio Historical Society marker honoring Steubenville native Edwin M. Stanton was dedicated in the Courthouse yard next to Stanton's statue from 1911. Stanton's great-great granddaughter attended the ceremony. (Photograph by Ron Smith.)

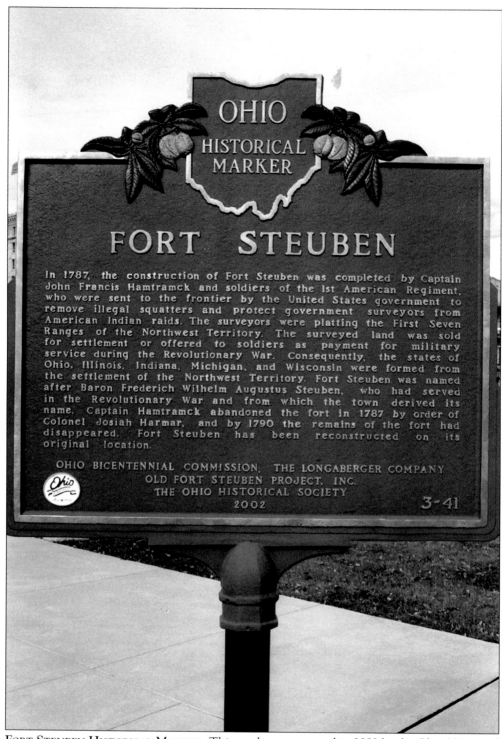

OHIO HISTORICAL MARKER

FORT STEUBEN

In 1787, the construction of Fort Steuben was completed by Captain John Francis Hamtramck and soldiers of the 1st American Regiment, who were sent to the frontier by the United States government to remove illegal squatters and protect government surveyors from American Indian raids. The surveyors were platting the First Seven Ranges of the Northwest Territory. The surveyed land was sold for settlement or offered to soldiers as payment for military service during the Revolutionary War. Consequently, the states of Ohio, Illinois, Indiana, Michigan, and Wisconsin were formed from the settlement of the Northwest Territory. Fort Steuben was named after Baron Frederich Wilhelm Augustus Steuben, who had served in the Revolutionary War and from which the town derived its name. Captain Hamtramck abandoned the fort in 1787 by order of Colonel Josiah Harmar, and by 1790 the remains of the fort had disappeared. Fort Steuben has been reconstructed on its original location.

OHIO BICENTENNIAL COMMISSION, THE LONGABERGER COMPANY
OLD FORT STEUBEN PROJECT, INC.
THE OHIO HISTORICAL SOCIETY
2002 3-41

FORT STEUBEN HISTORICAL MARKER. This marker was erected in 2002 by the Ohio Historical Society and the Longaberger Company to commemorate Ohio's Bicentennial. It stands in the park in front of the Visitor's Center. (Photograph by Ron Smith.)

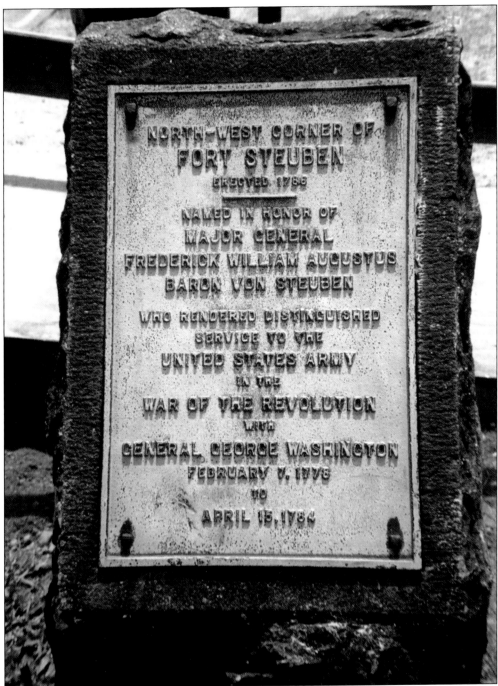

FORT STEUBEN HISTORICAL MARKER. This marker was erected in 1897 as part of Steubenville's Centennial Celebration. It designates the Northwest Corner of the original site of Fort Steuben and is today inside the reconstructed fort gate. Four similar markers were erected at each corner of the fort site after the area was researched by the Centennial Committee. In 1897, the site was covered with houses, commercial buildings, and railroad tracks. It would be another 80 years before opportunity allowed the fort to be reconstructed on the site. (Photograph by Ron Smith.)

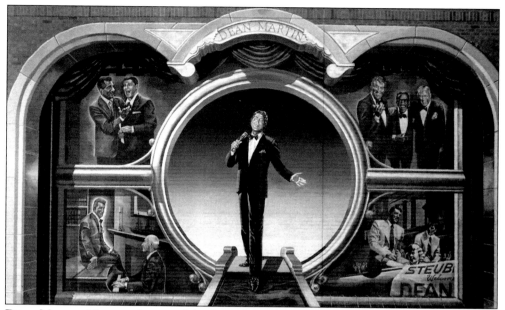

DEAN MARTIN MURAL. As part of the City of Murals Project, this mural of Steubenville native Dean Martin was painted on the side of the Kroger's Store in Hollywood Shopping Plaza. It depicts Dean Martin singing, as well as scenes from his life in show business. (Mural by artist Robert Dever, photograph by Ron Smith.)

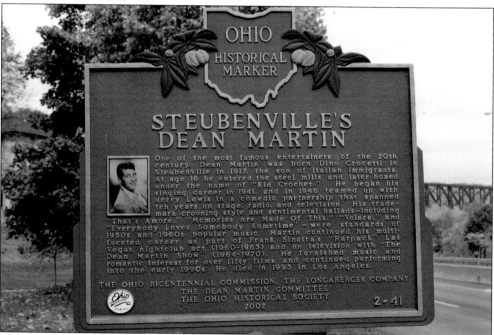

DEAN MARTIN HISTORICAL MARKER. Entertainer Dean Martin was born in 1917 in Steubenville. His real name was Dino Crocetti. This Ohio Historical Society Marker was erected along State Route 7 in 2002 to commemorate Ohio's Bicentennial and was sponsored by the Dean Martin Committee and the Longaberger Company. There is an annual Dean Martin Festival held in Steubenville every June. (Photograph by Ron Smith.)

DEAN MARTIN IN THE CITY DIRECTORY. Members of the Crocetti Family living in the city in 1940 are listed on page 172 of the 1940 Steubenville City Directory. Dean Martin, listed as "Dean Crocetti," born "Dino Crocetti," was living at 313 North 7th Street with his parents, Guy and Angela, and his brother William. Many of the other Crocettis named in the directory were cousins. This was the last directory to list Dean, or "Dino," as a resident of the city. (PLSJOC.)

172 BURCH DIRECTORY CO.'S

Crissinger Freda wks H M Borden w s Wilma ave
Crissinger Naomi E wks 314 Braybarton blvd
Crist Lewis W mech Moore Bros Inc h Mingo Junction O, R D 1
Crites Ivan N [Laura L] wks Weirton S Co h 525 Madison ave
Crites Walter L wks Moore Bros Inc h 525 Madison ave
Critico Spero wks Palace Restr h 333 S 3d
Critser Mrs Clara office sec Tri-State M S Co Inc h 1517 Foster pl
Critser Clarence K [Doris D] slsmn Union Dairy Co h 515 Union
Critser Ella M h 612 Dock
Critser Raymond M [Clara E] slsmn Union Dairy Co h 1517 Foster
 pl
Crocetti Archie wks Ohio F & M Co h 806 South
Crocetti Dean P entertainer h 313 N 7th
Crocetti Guy [Angela] barber h 313 N 7th
Crocetti James [Mary] wks Pure Milk Corp h 519 Slack
Crocetti John slsmn Pure Milk Corp h 806 South
Crocetti Joseph [Grace] slsmn Pure Milk Corp h 806 South
Crocetti Mary beauty opr Mary Jane B S h 806 South
Crocetti Robt h 519 Slack
Crocetti Wm A student h 313 N 7th

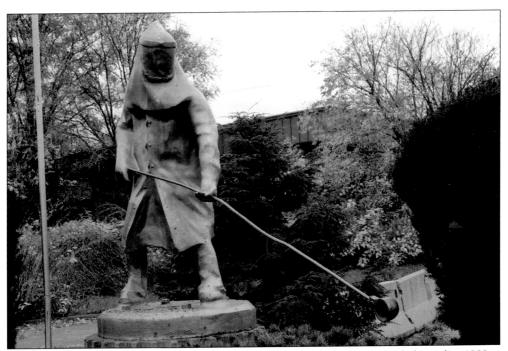

STEELWORKER STATUE. This statue honoring Ohio Valley steelworkers was dedicated in 1989 at Dean Martin Boulevard and University Boulevard. The 7,550 pound cast iron statue is covered in white gold leaf and depicts a steelworker in fireproof protective clothing, which would be worn when a worker was near the mouth of a blast furnace. The ladle is to depict a pouring of molten metal. The statue was made faceless so that it would represent all area steelworkers. (Photograph by Ron Smith.)

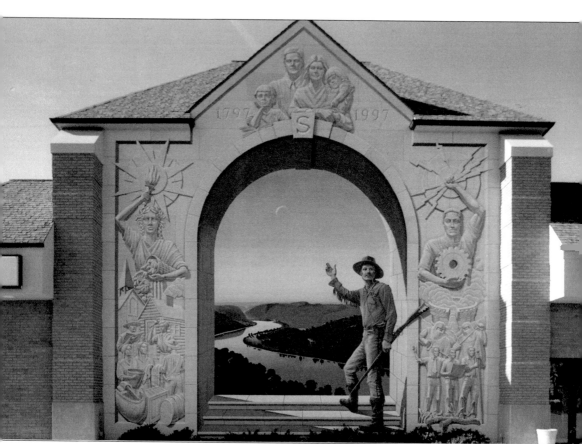

THE PIONEER. As part of the City of Murals Project, "the pioneer" was painted on Lenora's Restaurant in the Hollywood Shopping Plaza. The mural shows a pioneer stepping through the archway into the Ohio River Valley on his way to settling the Ohio Country. (Mural by artist Eric Grohe, photograph by Ron Smith.)

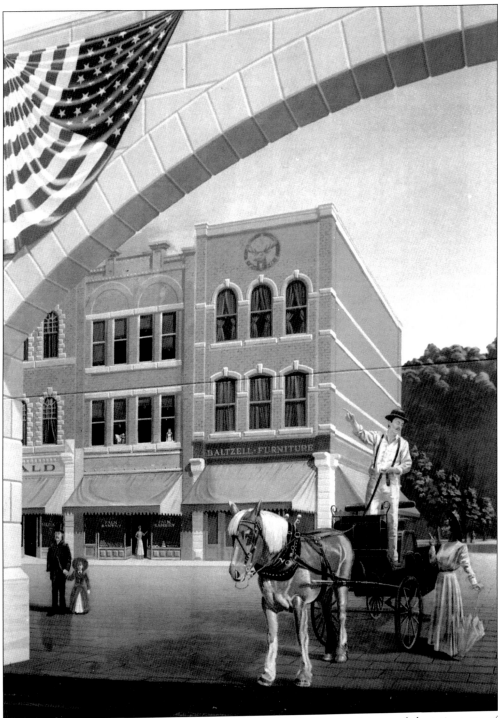

1897 CENTENNIAL ARCH. As part of the City of Murals Project, this mural depicting one of the 1897 Centennial Arches was painted on the side of a building along Washington Street. The photograph only shows part of the mural: a wagon passing through the arch celebrating Steubenville's 100th anniversary. (Mural by artist Eric Grohe, photograph by Ron Smith.)

BIBLIOGRAPHY

Andrews, J.H. *Centennial Souvenir of Steubenville and Jefferson County, Ohio, 1797–1897*. Steubenville, Ohio: Herald Publishing Company, 1897.

Doyle, Joseph B. *20th Century History of Steubenville and Jefferson County, Ohio and Representative Citizens*. Chicago, Illinois: Richmond-Arnold Publishing Co., 1910.

Holmes, John R. *The Story of Fort Steuben: a reconstruction of daily life in the Fort that opened the Northwest Territory, 1786–1787, based on original sources*. Steubenville, Ohio: Fort Steuben Press, 2000.

Howe, Henry. *Historical Collections of Ohio*. Cincinnati, Ohio: H. Howe & Son, 1889–91.

Ohio Department of Transportation (ODOT), Columbus, Ohio.

Photographs courtesy of Ron Smith, Steubenville, Ohio.

Photographs courtesy of Sandy Day, Wintersville, Ohio.

Public Library of Steubenville and Jefferson County, Ohio Room Collections (PLSJOC). Vertical File and Archival Materials.

Day, Sandy and Alan Hall, eds. *Steubenville Bicentennial, 1797–1997*. Apollo, Pennsylvania: Closson Press, 1997.

Steubenville City Directories. Various publishers, 1856, 1896, 1905, 1940.

Steubenville Herald Star newspaper. Steubenville, Ohio: Various names and publishers, 1806, 1818, 1820, 1889, 1899.

Steubenville, Ohio: the heart of the workshop of the world. Steubenville, Ohio: Germania Press, 1911.

Steubenville Sesquicentennial, 1797–1947: Veteran's Homecoming: July 2–6, 1947. Steubenville, Ohio: H.C. Cook Co., 1947.